words *of* wisdom

A Curator's *Vade Mecum* on Contemporary Art

words *of* wisdom

A Curator's *Vade Mecum* on Contemporary Art

Edited by Carin Kuoni

Independent Curators International (ICI)

New York

This book is published on the occasion of the 25th anniversary of
Independent Curators International (ICI), New York, and funded,
in part, by a grant from the Liman Foundation.

ICI is a non-profit organization dedicated to enhancing the understanding
and appreciation of contemporary art. Collaborating with a wide range of
eminent curators, ICI develops its program of innovative traveling exhibitions
and substantial catalogues to introduce and document new work in all mediums
by artists from the United States and abroad. Since its founding in 1975, ICI
has created nearly 100 exhibitions that have included work by more than 2000 artists
and have been presented by over 400 museums and other arts organizations
in the United States and eighteen other countries.

Independent Curators International (ICI)
799 Broadway, Suite 205
New York, NY 10003
www.ici-exhibitions.org

Library of Congress Catalog Number: 2001089702
ISBN: 0-916365-60-3

Text Editor: Stephen Robert Frankel
Designer: Bethany Johns Design
Translators: Marguerite Feitlowitz and Linda Philips (text by Mellado);
Karen Hanta (texts by Block and Curiger); Brian Holmes (text by Marí);
Susan Schwarz (texts by Ammann, Breitwieser, and Szeemann);
Jan Teeland (text by Lind)

Printed in Germany by Cantz

Distributed worldwide by D.A.P./Distributed Art Publishers
155 Avenue of the Americas
New York, NY 10013
Tel. (212) 627-1999
Fax (212) 627-9484

Cover:
Simone Martini, *Saint Luke*, 1330s
Tempera and gold leaf on panel, 22 $^1/_4$ x 14 $^1/_2$
Courtesy J. Paul Getty Museum, Los Angeles

Contents

Foreword and Acknowledgments

The inspiration for this book came about during conversations and reflections here at ICI on the changes in the field of contemporary art and curatorial practice during the last twenty-five years, and how they have mirrored the history of our organization. Independent Curators International was founded in 1975 with a passionate commitment to presenting innovative and challenging new art, making it accessible to a wide range of audiences, and creating a unique model to do this: a non-profit institution devoted to enhancing the understanding and appreciation of contemporary art without its own space, a kind of "museum without walls."

Over a quarter of a century, ICI has carried out this mission primarily through the presentation of almost one hundred traveling exhibitions of works in all mediums by more than two thousand artists and, in addition, the publication of catalogues for many of those projects in order to document them and expand their reach. Exhibitions are generally thematic in concept, each with a different "guest" curator, who may be independent or on the staff of a museum or other arts institution almost anywhere in the world; in fact, we have worked with curators from five continents. In this way, with the flexibility of creating exhibitions to fit nearly any gallery space and with a breadth of curatorial viewpoints, ICI has been deeply involved in international developments in contemporary art and curatorial practice, and has presented its exhibitions at more than four hundred arts institutions of all sizes across the United States and in eighteen other countries.

Since ICI was founded, schools of curatorial studies have sprung up here and abroad, advanced degrees in art history focusing on the art of the very recent past or present—degree programs that previously were almost completely unavailable—have become common, and hundreds if not thousands of new venues have opened for the

presentation of contemporary art around the world. Overwhelmingly, contemporary art is seen today in an international context, a shift from the more national focus that it generally had in the U.S. in 1975. Relationships have changed between artist and curator, curator and museum, artist and museum. Some critics have seen the development of what they call the "cult of the curator," and artists and curators have, at times, traded places. Amidst all of these developments, and at the moment of commemorating our twenty-fifth anniversary, ICI realized that a publication such as this one did not exist and that we could make a valuable and welcome contribution to this continually growing field—and especially to young curators—by creating one. Thus, we commissioned numerous brief essays to obtain "words of wisdom" from a wide range of experienced and distinguished curators, a number of whom have curated ICI exhibitions, and compiled their insightful, sometimes unconventional advice into this unique guide-book for the profession.

I would like to express my thanks to Carin Kuoni, ICI's director of exhibitions, who was instrumental in developing the concept for *Words of Wisdom*, and as project editor, piloted it through every aspect of its creation, from selecting contributors to choosing a cover illustration. Carin's vision for this project, combined with her knowl-edge and experience in the field, ensured that this publication would be the valuable resource we first envisioned.

Carin joins me in extending ICI's deepest appreciation to all the curators who generously contributed original texts to this book and whose enthusiasm for the project was gratifying. Each of them has played a crucial role in their profession in shaping the art that we see today and how we see it. We are honored to share their thoughts with the contemporary art community as a whole, and particularly with students and curators beginning in the field. We also wish to thank the members of ICI's Exhibitions Committee for their wholehearted support of this project and their advice on various issues during its development, and especially Joel Fisher for helping to crystallize the idea for this book in a conversation with Carin. She would also like to recognize the following individuals for feedback and suggestions

along the way: Daniel Faust, Henry Meyric Hughes, Felipe Mujica, Warren Niesluchowski and, in particular, John G. H. Oakes. We also wish to convey our warmest appreciation to ICI exhibition assistants Jane Simon and Sarah Andress. Thanks are also due to the book's editor, Stephen Robert Frankel, and to its designer, Bethany Johns, both of whom have once again made vital contributions to an ICI publication.

This book was made possible, in part, by a grant from the Ellen Liman Foundation, and it is my great pleasure to acknowledge this important and generous contribution.

Finally, I want to express my gratitude to the members of ICI's Board of Trustees for their active involvement and support, and to salute their enduring commitment to bringing challenging new art to a diverse national and international audience.

Judith Olch Richards
Executive Director, ICI

Introduction

Carin Kuoni

This handbook for beginning curators is a thing that is not meant to exist—if one were to heed the advice provided by many of its contributors—and thus is essentially a paradox. From the sixty essays assembled here, two main lessons might be drawn: first, that no rules exist in the field of curatorial work and, second, that curating an exhibition of contemporary art only addresses issues of the particular moment in which the exhibition was created. To attempt, however modestly and arbitrarily, to present some of the important curatorial strategies of the last twenty-five years—as we have done in this book—runs counter to this ahistorical outlook.

With a certain degree of irreverence and a lot of curiosity, qualities that have propelled ICI since its founding a quarter of a century ago, we nevertheless ponder the unattainable. The vade mecum—originally a medieval trade manual ("go with me" is the literal translation of the Latin term)—serves as an apt metaphor for our undertaking. Especially popular from the sixteenth through the eighteenth centuries, the vade mecum was an easy-reference manual that served as a guide to many aspects of life's challenges, often featuring images in equal proportion to text. Among the early titles were books such as *Vade Mecum: A Manuall of Essayes Morrall, Theologicall* (1629); and poets even made references to such manuals, as John Donne did in 1631 ("His vade mecum, the abridgment of all nature and all law, his own heart, and conscience"), and Lord Byron in his *Don Juan* in 1818 regarding Aristotle's rules ("The vade mecum of the true sublime,/ Which makes so many poets, and some fools").

In its most basic form, the vade mecum introduced some kind of uniform professional standards in a largely illiterate society. The book accompanied the itinerant worker and served as a manual with specific instructions as well as inspirational device. In that function, it seems to be loosely connected to the devotional book of hours,

both being portable and essential to the material and spiritual well-being of its owner.

We hope the words of wisdom collected in this little volume will be equally useful to a profession whose roots may not go back quite as far as some others, yet has its own professional pedigree. In fact, contrary to common perception, the curator of contemporary-art exhibitions is not a brand-new phenomenon but a vocation that has developed significantly over the last century. The American "curator" is variously called, in Germany, *Ausstellungsmacher* ("exhibition maker," a rather basic, hands-on definition); in France, *commissaire*, a term that acknowledges the institutional frame of the curator's activities; and, in England, "keeper" and "conservator," both placing an emphasis on the curator's caregiver role. *Words of Wisdom* was specifically created to capture some of the more established positions in curatorial strategies over the last quarter century and to pass them on to a generation of younger curators, some of whose concepts are represented here as well. All along, the intention was to provide not a chronology or a set of guidelines but inspiration to students and other professionals in the field. Like the medieval craftsman, the curator of contemporary-art exhibitions is often an itinerant. And while usually not illiterate, he or she still focuses mainly on images of some kind.

In inviting the curators to contribute their thoughts, we suggested a few questions that they might want to consider, focusing on such factors as audience, funding, institutional frame, personal experience, information exchange, and responsibility/accountability (see the list of questions on page 19). E-mail, being informal, personal, and immediate, turned out to be the perfect vehicle for transmitting quickly jotted-down ideas. In collecting them together and making them available to you, we wanted to create something that is as portable as the laptop computer; therefore, we opted to publish this old-fashioned, printed vade mecum in the convenient format of a small, easy-to-carry book.

Reflecting the volatile nature of contemporary art, and ICI's own coming-of-age in a certain context and at a certain moment, the selection of curators in this book is bound to be arbitrary and personal. Independent Curators International is a unique, swift instrument, readily available for the exchange of exhibitions and curatorial ideas. And often enough, ICI's program identifies and reflects the cutting-edge artistic and curatorial developments happening beyond its immediate doorsteps. Soon after international exchanges were being organized in the late 1970s and early 1980s—for example, Jean-Hubert Martin's seminal *Paris–New York* (1977), *Paris–Berlin* (1978), and *Paris–Moscou* (1979) exhibitions —we were doing our own cross-border swapping with exhibitions such as *Sculpture from Germany* (1983–85, curated by Michael Klein). Seth Siegelaub's "exhibitions" in art magazines, on postcards, and in books found a spiritual partner in ICI's exhibition *Language and Structure in North America* (curated in 1978 by Richard Kostelanetz). One of the first exhibitions to look at how artists work with maps was Peter Frank's ICI exhibition *Mapped Art: Charts, Routes, Regions* (1981–83).

Not least for political and economic reasons, much of the established history of contemporary-art exhibitions from the 1960s through the mid-1980s reads today like a cross-Atlantic exchange, mainly involving the United States and Europe. The late 1980s brought us the first major attempts at truly multi-cultural exhibitions such as Jean-Hubert Martin's *Les Magiciens de la Terre* in Paris (1989) and, in New York, *The Decade Show* (1990, curated by Marcia Tucker and others). ICI's contribution to this new perspective consisted of exhibitions such as *Through the Path of Echoes: Contemporary Art in Mexico* (1990–93, curated by Elizabeth Ferrer). In the middle of the so-called "culture wars" in the United States—the battles over government funding for controversial art, provoked by the cancellation of an exhibition of Robert Mapplethorpe's photographs at the Corcoran Gallery in Washington, D.C. (1989)—ICI launched a distinct and ground-breaking line of activist, issue-oriented exhibitions, with Lucy Lippard's *A Different War: Vietnam in Art* (1989–92), Nina Felshin's *No Laughing*

Matter (1991–93), and *From Media to Metaphor: Art About Aids*
(1992–93), curated by Robert Atkins and Thomas Sokolowski. Another
type of corrective of art history was provided by the retrospective
Meret Oppenheim: Beyond the Teacup (1996–97), curated by Jacqueline
Burckhardt and Bice Curiger, presenting a more complete vision of
an artist whose seminal work was utterly unknown in the U.S.—
with the exception of the famous fur-lined teacup in the collection
of New York's Museum of Modern Art.

The site-specific exhibition, another battle cry of the 1990s, acquired
a firm footing with Mary Jane Jacob's project *Places with a Past*, in-
stalled throughout the city of Charleston in South Carolina (1991).
A corollary of this idea has altered the concept even of the traveling
exhibition: aside from the artists working directly with a particular
site and/or members of a community, it is in the absence of the artists
members of the community itself that can execute the artworks, thus
creating a truly "local" connection. ICI projects such as Nina Felshin's
Presence of Absence (1989–93) and Hans-Ulrich Obrist's *do it* (1997–
2001) are both based on the participating artists' instructions on
how to create a specific artwork.

Before the advent of the World Wide Web, art based on new media
was generally understood as video-based works, which were given a
forum early on in New York by the Whitney Museum's lively video
programs. ICI exhibitions such as *Video Art U.S.A.* (1976, curated by
Jack Bolton) and *Eye for I: Video Self-Portraits* (1990–92, curated by
Raymond Bellour) contributed to the general understanding of this
new medium. They were followed by more historical assessments
provided by exhibitions such as ICI's *The First Generation: Women and
Video, 1970–1975* (1993–95, curated by JoAnn Hanley). In Europe, the
ZKM (Zentrum for Kunst und Medien) in Karlsruhe established the
World Wide Web as the next artistic frontier. Several years later in the
United States we are at the same point, with Larry Rinder's *BitStreams*
(2001) and ICI's own *Telematic Connections: The Virtual Embrace*
(2001–03, curated by Steve Dietz). The latter is one of the first exhibi-
tions to present both installations and online sites that use the com-

munications network and computing to explore a specific theme, that of their potential for communication.

Collectively, the authors of the texts in this *Vade Mecum* (some of whom curated the exhibitions mentioned above), present a diverse set of thoughts about curating—as varied as the range of their exhibitions. As impossible as it is to summarize the art of the last twenty-five years in definitive terms, even if we were to limit ourselves to what has surfaced in exhibitions, it is similarly difficult to provide an adequate synopsis of the contributors' myriad views.

The role of the curator as we examine it here is linked to the term "contemporary art." Jérôme Sans concludes his text with an observation about how "difficult it is to curate an exhibition of the work of deceased artists, or even of living artists, if we don't have their active participation." This may be one of the most frequently recurring themes in the book: the pleasure, necessity, quality, challenge, and unique privilege of working with the artists themselves, which any exhibition of contemporary art potentially offers. Such a collaboration can take many forms. While some curators let artists select their contributions, others shape an environment that enables the artist to develop his or her work. Others send artists out to gather "experience" and return to the museum with the fruit of their labor; still others emphasize the importance of friendships, where the success of an exhibition depends largely on the compatibility of the curator's and the artist's personalities. Some curators assign key artists a leading role in defining an exhibition; others will look at an artwork first before talking to those who made it.

The range of viewpoints presented here extends to the definition of "artwork," which is described at one extreme as an "inert, passive object" and at another as a "holy presence, and not an artifact," thus providing to those who view it a spiritual encounter. Many curators believe that art can never be comprehensible, that it "yields experience that reconciles pleasure with knowledge in counterintuitive ways."

This potential for surprise in any artwork is mined by many of the curators, not simply as a source of information but pursued as a curatorial strategy to develop an exhibition's theme and layout.

The curator's responsibilities are obviously manifold. The curator is seen as a cultural agitator in his or her multi-tasked role, a role of growing economic importance, as some contributors contend. He or she is a "cultural communicator," a "broker of cultural goods," a high priest of the arcane, a "midwife" as "mad as the artist." To a certain degree, spiritual awareness and even wisdom are required: extroverted and alert, introverted and instinctive, the curator is guided by knowledge and intuition. The curator is also seen as a visual anthropologist, in a position to furnish a corrective to the established canons of art history, an alternative history parallel to that consecrated by the art market. The border to psychology is nearby: several contributors emphasize the necessity to be true to oneself, to determine one's interests, and to stick with them over the years. Some call the experience of curating "identity-affirming."

Listening to the younger curators, what is perhaps most striking is their call for long-term investment, not just in the relationship with artists and art but in the exhibition itself. In these scenarios, the exhibition is a changing, volatile, developing construct, continuously connected to a multitude of sources of art and information, where confusion, contradiction, friction, and surprise play key roles. This new kind of exhibition consists of the entire discourse leading up to, accompanying, and following the actual presentation of artworks— artworks defined here in the broadest possible sense. Such exhibitions incorporate communication channels (such as Web sites, chat rooms, public forums, etc.) through which the public can report back on their exhibition experience and thereby affect subsequent presentations. Moreover, because of their dense, multi-layered concepts and installations, they accommodate different viewing "styles" simultaneously. But exhibitions of this kind also have repercussions in the world outside the museum; the call for the curator to exercise a high degree of social responsibility and for exhibitions that acknowledge the

inherently political stance of any public event ("There is no 'pure' gaze") comes particularly strongly from countries outside the U.S.

These new exhibitions may sometimes require new institutions, institutions that provide equally flexible systems and environments. Here, the potential for a new model might be found, somewhat unexpectedly, in the biennials and triennials—or in traveling exhibitions from an organization without a fixed curatorial viewpoint or a permanent exhibition space, such as ICI.

A live debate among sixty curators could only happen in the rarest of circumstances. We hope that the spirited, opinionated contentiousness of such a debate is captured in the following pages, and that it will prove to be a useful vade mecum, albeit one filled as it is with contradictions.

Caveat emptor.

An art critic, curator, and the director of exhibitions at ICI, Carin Kuoni was formerly the director of the Swiss Institute, a non-profit cultural institution in New York. Kuoni is the editor of *Energy Plan for the Western Man: Joseph Beuys in America* and has curated and co-curated many exhibitions, including *Common Houses: Siah Armajani and Hannes Brunner, Time Wise,* and *Chocolate!* She is currently working on an exhibition for ICI called *Thin Skin.*

Words of Wisdom: A Curator's Vade Mecum on Contemporary Art

Some Questions to Consider

1. What is the single most important piece of advice you can offer to a beginning curator of contemporary art?

2. What kind of exhibition should be done today? (What do we need to see?)

3. Which exhibition would you most like to curate, disregarding any practical issues such as finances, lenders, presenters, etc.?

4. For whom do you curate, to whom (or what) are you accountable?

5. Which do you consider your most important exhibitions, and for what reasons?

6. What is the responsibility of a curator?

7. How did you develop your curatorial skills? (What were some of the most important concepts/exhibitions you absorbed? When?)

8. What do you consider the most important tools of a contemporary-art curator?

9. Which moment do you curate for? (For now or posterity; are you capturing the zeitgeist, or shaping the future?)

10. A temporary construct to begin with, how does an exhibition travel best?

11. What have been the major changes in the role of the curator over the last twenty-five years?

12. How important is curatorial mobility?

Jean-Christophe Ammann

Some Suggestions for Beginning Curators

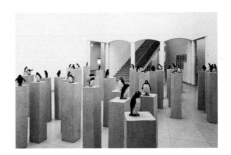

Work by Stephan Balkenhol in
Change of Scene 2, Museum für
Moderne Kunst, Frankfurt, 1992–93

1. Trust the art, not the discourses generating the "art."

2. Examine art for its potential, not the redundancy that transports
the art (market, trends, name dropping).

3. Go to the artists and question them; look over their shoulders.

4. Define your own identity. Don't confuse your desire to be on
everybody's mind with the desire of what moves you deep down.

5. Approach your task with an idea. The stronger the idea, the
easier it is to turn it upside down, given the appropriate degree
of openness.

6. Keep the works' feasibility in mind. (There is nothing more
depressing than a work that fails because it can't be realized, especially
when its non-functioning is then used to explain the artwork.)

7. Think of the overall picture of an exhibition: Is it just a mass
of details? Or is there a sense of coherence that conveys a particular
impression?

8. Follow the example of Claude Lévi-Strauss in his metaphor
of sitting at the window and watching, examining all the things
that he sees for their relevance with respect to dialogue, emotion,
and cognition.

9. Enlighten yourself and you will enlighten the viewer.

10. Never put up a work for discussion; believe in it because you're convinced.

11. Think anti-cyclically!

12. Never confuse the art of exhibiting with art. It is possible for some exhibitions to become art; however, an exhibition should not be considered art simply because it "contextualizes" the ephemeral.

13. Don't ever forget that even an artist who questions the notion of a work of art, or even renounces it, is bound to think about a retrospective of his or her own artworks ten years down the road.

14. Try to identify the zeitgeist, and evade it. Let's call the zeitgeist Z, and the original substance of the work (its quality) S. At present, both may seem equal:

$$Z \; I \; S$$

A few decades later, the following situation has developed:

$$\text{either} \quad \mathbf{Z} \; I \; s$$

$$\text{or} \quad z \; I \; \mathbf{S}$$

In the first case, the zeitgeist dominates, and the substance, the original quality, disappears. In the second case, the substance dominates, and the zeitgeist fulfills the sole function of situating the work in its time and space. Art history is full of such examples. In one case, we are dealing with documents, in the other with artworks.

15. Be yourself. Don't try to be different from others; be different just by being yourself.

16. Knowledge and information are one thing; intuition is another. Train your intuition. The training of intuition is a discipline that is connected with intellectual curiosity and hunger for life; when intuition explores new horizons, it always leads to wisdom.

17. Try to think in the present tense, in the sense that you can think of the precise as diffuse and the diffuse as precise.

18. Make sure you have a good team. Don't try to do everything yourself.

19. Organization is important. Step-by-step, list all the things that need to be done and taken into account. Early coordination and logistics will save you money and energy.

20. Tell the artists what you want.

21. Presentation is the alpha and omega. Listen to the artwork, and let it guide you. The artwork needs to find its partner. Consider yourself a "matchmaker."

22. View the works as beings with their own specific energy. When deciding where the works will go in an exhibition, calculate down to the quarter-inch the distance between them (some need more, others less space), and determine the exact installation of each object. It will vary from space to space depending on the size of the work and of the space. Give the space an identity through the work: give it the identity *of* the work.

23. Put yourself in the shoes of an unprepared viewer.

24. Bear in mind that the adventure doesn't really begin until the opening of the exhibition. From then on you'll be providing continuous support for the exhibition and acting as a mediator between the art and the public.

25. There's no question that the catalogue is important, but don't make it more important than the exhibition. The catalogue is not meant to justify the exhibition; but the exhibition should be worthy of the catalogue.

26. Always remember that there are no stupid questions, only stupid answers.

Jean-Christophe Ammann, born 1939, Berlin, Germany
Current position: Director, Museum für Moderne Kunst, Frankfurt, Germany. **Former positions** include director, Kunsthalle Basel, and director, Kunstmuseum, Lucerne, Switzerland. **Selected exhibitions**: *Carnegie International* (co-curator, 1988, Pittsburgh, Pennsylvania); *Giovanni Anselmo* (1979, Kunsthalle Basel); *Paul Thek: Ark, Pyramid, Easter* (1973, Kunstmuseum, Lucerne); *documenta 5* (co-curator, 1972, Kassel, Germany). **Selected publications**: *Annäherung: Über die Notwendigkeit der Kunst* (Regensburg, 1996); *Rémy Zaugg–Gespräche mit Jean-Christophe Ammann* (Stuttgart, 1994)

Bart de Baere

The Curator as a Beginning, Not an End

Works by Jason Rhoades and
Honoré d'O in *This Is the Show and
the Show Is Many Things*, 1994

It seems that as a curator in Brazil you easily get large articles written
about you in the newspapers. Once, when I traveled from there to Chile,
the staff at the hotel where I was staying glanced through some of
those newspaper interviews. They reacted with awe, seeing my photo,
interpreting the word *curadores* in the titles as "healers." They were
entirely wrong, weren't they?

In preparing large exhibitions, a curator must focus primarily on
two things: the overall concept of the show and the list of selected
artists. Both are invalid: to steer and to decide—what a distorted idea.
I believe that the real work of a curator is of a different nature. A cura-
tor is a mediator who aims to transmit the energy emanating from art.

The idea of the "concept" renders invisible the transformation of
an exhibition from an amorphous idea to a concrete reality. First of
all, it is already an abstraction of the initial impetus for the exhibition
and therefore unavoidably a variation of the tradition of art, in the
best of all cases at least reflecting on how this tradition continues,
perhaps even trying to twist and challenge it. Such exhibitions may,
in fact, take up seemingly loose ends within the initial amorphous
idea and provide a legitimization for them. Second, the focus on a
"concept" makes it difficult to appreciate the decisive role of the artists
in an exhibition of contemporary art, through their direct participation
in the show. Even artworks by themselves have this effect.

The idea of "selecting artists" to be featured in an exhibition renders invisible the aspect of mutual choice, engagement, communication. The artists who are essential for the success of the exhibition are those whom the curator believes can realize an undertaking. Their refusal would mean a certain loss. This belief is, for me, at the heart of curating. It is no longer just about you and your decisions, but about the collaborative effort by both you and the artist(s) together, through which you assist one another. This mutual respect obviously remains critical. You assist one another also by expressing doubt, disbelief, disappointment; this is part of the symbiotic engagement. To the world, you speak a hypothesis of art; to the artists, a hypothesis of the world.

Of course there are events in which the aim is to propose a reductive concept or a list of names. These don't need a curator. They can do with a theoretician or a critic, a producer or a manager.

A curator has to shape the environment in which things can happen, in which artists can develop proposals that were unthinkable beforehand, in which works of art can reveal the exhibition's concept as simplistic, in which the image of the work of art can unfold, in which an audience can reinterpret an exhibition and transform its meaning to fit the new context of which that audience is a part.

The curator is the starting point of a project but not its source, and throughout the curatorial process his or her aim may be to disprove the initial assumption(s) and have it/them replaced by a network of communications that continuously redefine the raison d'être of a project.

Bart de Baere, born 1960, Vilvoorde, Belgium
Current positions: Advisor for the Visual Arts and Heritage to the Flemish Minister of Culture; Curator, Stedelijk Museum voor Actuele Kunst (SMAK), Ghent, Belgium. **Former positions** include co-curator, *documenta IX*, Kassel, Germany. **Selected exhibitions**: *Europe*, in São Paulo *Bienal* (co-curator, 1998); *Onder Anderen*, in Venice *Biennale* (co-curator, 1995); *Honoré d'O, Hugo Debaere, Billy Mandindi, Rik Moens, Albert Munyai*, in Johannesburg *Biennial* (co-curator, 1995); *This Is the Show and the Show Is Many Things* (1994, SMAK). **Selected publications**: "The Presence of Art as a Reference for Society," in *Cultural Management* (Stockholm, 1994); "The Integrated Museum," in *Stopping the Process? Contemporary Views on Art and Exhibitions* (Helsinki, 1998)

Carlos Basualdo

Figures of the Future

Work by Peter Kogler in *Painting Zero Degree*, Cranbrook Art Museum, 2000

The cultural effectiveness of a practice is a function of the degree of freedom that people pursuing that practice enjoy in a specific socio-economic and historical context. I have always been of the opinion that curatorial practice today, because of its very interstitial and unstable nature, possesses at least the same potential in terms of its effects in the cultural field that artistic practice used to have—and maybe more. Having said that, it would be difficult to pin down the term "curatorial practice" under a clear-cut and distinct definition. There are museum curators and independent curators; there are people who become curators on occasion just to put together a specific exhibition; and there are tons of people who will never think of them-selves as curators but at some point or another operate like them. In fact, most people who call themselves curators are so confined by a narrow system of conventions that they end up enjoying almost no freedom in the large scheme of things and, in cultural terms, are com-pletely ineffective. Circumscribed by conventions, they end up being the very embodiment of those conventions: distracted authors of boredom, of an academic or commercial nature (funny that those two apparent opposite extremes of bourgeois life are becoming more and more like each other), who just simply do what they are supposed to.

In contrast to museum curators, who are usually slow, independent curators constantly run the risk of going too fast, dissolving the very possibility of their thinking while standing at airline ticket counters or sitting in airplanes stuck on airport runways. On one end of the spectrum the bureaucratic desk, on the other the volatility of thin air . . . Finally, the "occasional curator," though sometimes extremely incisive, is also limited by the ephemerality of her interventions: any statement needs a certain degree of repetition in order to become apparent. The obvious conclusion is that the curator as a cultural agitator, and a thinker in and of history and space, is less a reality than something we wish for, something that might happen at some point. But that is not entirely correct: it happens, now, and it also has happened, in the past. Curatorial practice as a cultural proposition is here to stay, but the curator as a subject shaped by and shaping that kind of practice is still largely absent. And this mainly because the current institutional arrangement still doesn't have a place for her, too embedded as it is in old definitions of art and its role in the life of society. Then, it is our job not only to eventually become those curators, but also to create the fluid institutional framework where such curators could operate: an ever-changing structure—challenging and challenged—that will require their presence in order to exist.

Carlos Basualdo, born 1964, Rosario, Argentina
Current positions: Chief curator of exhibitions, Wexner Center for the Arts, Columbus, Ohio; co-curator, *documenta 11*, Kassel, Germany; international program coordinator, Apex Art Curatorial Program, New York. **Selected exhibitions**: *Hélio Oiticica: Quasicinemas* (2001, Wexner Center); *Eztetyka del Sueno* (2001, Museo Nacional Centro de Arte Reina Sofía, Madrid); *Worthless (Invaluable)* (2000, Moderna Galerija, Ljubljana, Slovenia); *Painting Zero Degree* (2000–02, ICI traveling exhibition); *Tunga: 1977–1997* (1997, Center for Curatorial Studies, Bard College, Annandale-on-Hudson, New York)

René Block

Never Play Sorcerer's Apprentice

Work by Daniel Buren in *Das Lied von der Erde*, 2000

The curatorial profession is only a few decades old. The first exhibition organizer to work like a real curator was Arnold Bode. He founded *documenta* in Kassel in 1955 and defined the character of this seminal German art show in that and the next three exhibitions (in 1959, 1964, and 1968). At the end of December 2000, Bode would have been one hundred years old. The German postal service marked the occasion by issuing a stamp in his memory; he was the first curator ever to receive such an honor.

Bode secured his place in history through his masterful skills in staging exhibitions. His most innovative accomplishment as a curator was to open up new avenues for artists to show their works, especially outside the white cube of museums and galleries. Bode achieved this by paying the utmost respect to the art and by not compromising his vision. He planned with his head in the clouds but had both feet firmly planted on the ground. Today, the levity and transience of contemporary art would have driven a man like Bode to despair.

Bode would also be disheartened by the strategies employed by many of today's artists and curators. A curator's job does not involve wizardry, but requires a wealth of experience and knowledge, responsibility, and a good overview of artistic developments. But if we are lucky, we curators still manage to enchant visitors with the results.

 René Block, born 1942, near Düsseldorf, Germany
Current position: Director, Kunsthalle Museum Fridericianum, Kassel, Germany. **Selected exhibitions**: *Das Lied von der Erde* (2000, Fridericianum); *Eurafrica*, in Kwangju *Biennial*, Korea (2000); *Echolot* (1998, Fridericianum); *Pro Lidice* (1997, Museum of Fine Arts, Prague); *Orient/ation*, in Istanbul *Biennial* (1995); *Über Malerei* (1993, 300th Anniversary of the Akademie der Bildenden Künste, Vienna); *Mit dem Kopf durch die Wand* (1992, Statens Museum, Copenhagen); *Medienkunst* (1991, National Gallery, Seoul); *The Readymade Boomerang*, in Sydney *Biennial* (1990)

Francesco Bonami

Works by Udomsak Krisanamis,
Suchan Kinoshita, Chris Moore,
and Rudolf Stingel in *TRUCE*, 1997

1. *What is the single most important piece of advice you can offer a beginning curator of contemporary art?*
Do it! For the first show I curated entirely by myself—*Campo 95*—
I put the shipping costs on my AmEx and I got funding one week
before the show opened in Venice.

2. *What kinds of exhibitions should be done today? (What do we need to see?)*
We need to see all around us, not simply ahead of us, so look around
over and over and try to build an exhibition that will open more than
one door, even the door of possible failure.

3. *For whom do you curate?*
When you curate, you never win. If you curate for a general audience,
you'll be accused of being simplistic; if you curate for the art world,
you will be accused of bringing too few people in; if you curate for
yourself, people will say "Who cares." So be ready to say something,
and if you have nothing to say, don't do the show.

4. *Which do you consider your most important exhibitions, and for what reasons?*

TRUCE, the second *Biennial* at SITE Santa Fe (1997), and *Unfinished History* at the Walker Art Center (1998). Both, at different levels, gave me the opportunity to deal with a broad vision and also to experience the United States as a fertile ground in which to establish my language. I am an immigrant and an outsider, so those two shows provided me with new roots and new important relationships. For me, a show is always an opportunity to establish relationships, even if at times you end up with disappointing results—i.e., when the artists hate you, and you hate the artists—but that's part of the game.

5. What is the responsibility of the curator?
To create a legacy.

6. How did you develop your curatorial skills? (What were some of the most important concepts/exhibitions you absorbed? When?)
I am a self-made curator. I have developed my skills in the field, mostly in the process of curating *Aperto '93* in Venice.

7. What do you consider the most important tools of a contemporary-art curator?
Be focused, forget about the press, forget about the audience, and hope that you'll get a lot of people to see your shows and that you'll receive some decent feedback.

8. Which moment do you curate for?
I curate for the present, and I think that if you are successful you also do something that will affect the future.

9. A temporary construct to begin with, how does an exhibition travel best?
In crates or on paper; by the latter, I mean just as a project to be reinvented over and over. I think *Cities on the Move* (1997–2000), curated by Hans Ulrich Obrist and Hou Hanru, was a good example of a project that is in constant metamorphosis.

10. *What have been the major changes in the role of the curator over the last 25 years?*
The realm of art has become a huge panorama, and there are no longer any specific movements. Also, the role of the curator today involves such enormous geographical diversity that the curator is now a kind of visual anthropologist—no longer just a tastemaker, but a cultural analyst.

11. *How important is curatorial mobility?*
You must move, and you must talk (but not too much), and you definitely must listen.

One final suggestion: never fear the younger generation—that's where the energy comes from. If you ignore them or keep them out, you'll have missed the boat.

Francesco Bonami, born Florence, Italy
Current positions: Manilow senior curator, Museum of Contemporary Art, Chicago; artistic director, Pitti Immagine, Florence; artistic director, Fondazione Sandretto ReRebaudengo, Turin. **Former positions** include U.S. editor, *Flash Art International*. **Selected exhibitions**: *Manifesta 3* (2000, Ljubljana, Slovenia); *Delta* (1998, Musée de l'Art Moderne de la Ville de Paris); *Unfinished History* (1998, Walker Art Center, Minneapolis); *TRUCE: Echoes of Art in an Age of Endless Conclusions*, second *Biennial* at SITE Santa Fe, New Mexico (1997); *Campo 6* (1996, Fondazione Sandretto ReRebaudengo). **Selected publications**: *Maurizio Cattelan* (London, 2000); *Sogni/Dreams* (co-editor, 1999); *TRUCE: Echoes of Art in an Age of Endless Conclusions* (Santa Fe, 1997)

Saskia Bos

Answers for *Words of Wisdom: A Curator's Vade Mecum*

Work by Allen Ruppersberg (on floor) installed at De Appel Foundation

(Answers by Saskia Bos together with the members of the De Appel Curatorial Training Program 2000–2001: Hilde de Bruijn, Netherlands; Barbara Clausen, Austria; Dominique Fontaine, Canada; Illina Korolova, Bulgaria; Livia Paldi, Hungary; and Nuno Sacramento, Portugal)

1. What is the single most important piece of advice you can offer a beginning curator of contemporary art?
Establish and keep contact with several artists of your own age but also with artists of other generations.

2. What kinds of exhibitions should be done today? (What do we need to see?)
A show that could, for example, portray the role of the Internet, in relation to contemporary art. Also a show that focuses on inter-disciplinary subject matters, emphasizing the elements connecting the different disciplines.

3. Which exhibition would you most like to curate?
An exhibition where artists can develop new works in cooperation with the curator and the location.

4. *For whom do you curate?*

For both the artist and the audience, in balance.

5. *Which do you consider your most important exhibitions, and for what reasons?*

Exhibitions should be made at the right moment: not too early and not too late. This goes both for solo exhibitions and for group exhibitions with a theme.

6. *What is the responsibility of the curator?*

To be able to deal with the discrepancy between ideals and practical reality while at the same time maintaining his/her position or ideas.

7. *What do you consider the most important tools of a contemporary-art curator?*

The international network and a curator's mobility, as well as the awareness and knowledge of contemporary artists.

8. *Which moment do you curate for? (For now or posterity; are you capturing the zeitgeist, or shaping the future?)*

For the present, with the aim of capturing the zeitgeist in a way that could also shape the future.

9. *A temporary construct to begin with, how does an exhibition travel best?*

Stringent and compact in its nature, the traveling exhibition should ideally still be able to adapt to the context of its placement and should involve the artists as well as the curator in this process.

10. *What have been the major changes in the role of the curator over the last 25 years?*

It seems that the curator has become a star, but this is only true for a few curators who have had extensive press coverage and are therefore "hired" by city governments to make their cities shine. The real lead is taken by management-directors who franchise museum brand names and whose focus is more on the hardware.

11. *How important is curatorial mobility?*

Mobility can be helpful to a curator, who can develop his or her methodology by working in different institutions; and it is essential to a curator, who must travel in order to do research and see art in its given context.

Saskia Bos is director of De Appel Foundation, Amsterdam.

Sabine Breitwieser

A Career and a Calling among Entertainment, Market, and Science

Works by Ernst Caramelle, Peter
Weibel with VALIE EXPORT,
Peter Weibel alone, and Gottfried
Bechtold in *RE-PLAY*, 2000

I can't say I wholly identify with the job title "curator." Outside the
artworld (that is, in the non-art world), due to the unequal balance
of power, the word "curator" is used to connote a person having care
and superintendence of something, a kind of custodian, a person
presented with a judicial decision, as it were, in order to formally
represent another person in all affairs and administrate his or her
assets. Why is it that this term has become common as a job title
during the last twenty years, when the activity of "making exhibitions"
evolved into a profession? It seems it must have to do with the claim
and reality of power. Am I "in," or not? The answer can be decisive
for individual artists.

Personally, I try to use this power to provide a certain degree of
correction with respect to the assessment of individual artists, art-
works, or movements, working in parallel to the laws of the free-
market economy. As idealistic as that may sound, I soon came to
realize that even with this approach I am doing the groundwork
for the market. Every successful show generates salable artworks,
products that until then weren't recognized as such.

Producing exhibitions can be very costly and time-consuming.
Often, nearly the only thing left when the show is over is the cata-
logue, and after a relatively short time, it, too, hardly arouses interest

anymore—assuming it ever did to any appreciable degree. Some exhibitions get a good response, but in my opinion many of them are more or less representative of a new sector of the entertainment industry. It makes you wonder why the people behind the show didn't go straight to Hollywood, were working conditions and salaries are better.

Occasionally, we witness the emergence of subjects, artists, and works that many recognize as truly consequential. But time after time, they still float around without being taken up and made into an exhibition. This is where my enthusiasm and curiosity come in, the energy I hope to share with as many people as possible in a show and a publication. For me, as for many others, one of the most important sources is talking to artists. More often than not, they are the ones with the most interesting ideas and approaches.

Sabine Breitwieser, born 1962, Wels, Austria
Current positions: Artistic and managing director, EA-Generali Foundation, Vienna, Austria; lecturer, University of Applied Arts, Vienna. **Former positions** include curator, EA-Generali Foundation. **Selected exhibitions**: *Vivências/Life Experience* (2000, Vienna); *RE-PLAY: Beginnings of International Media Art in Austria* (2000, Vienna); *Martha Rosler: Positions in a Life-World* (co-curator, 1999–2000, EA-Generali Foundation, traveling exhibition); *Mary Kelly: Post-Partum Document, the Complete Work (1973–79)* (1998, Vienna); *Pichler: Prototypes 1976–69* (1998, Venice); *Reorganizing Structure by Drawing Through It: Drawings by Gordon Matta-Clark* (1997–99, EA-Generali Foundation, traveling exhibition)
Selected publications: Catalogues for the exhibitions listed above (and others); *Erziehungskomplex/Educational Complex* (Vienna, 1997); *White Cube/Black Box* (Vienna, 1995); *Andrea Fraser: A Project in Two Phases (The EA-Generali Foundation Headquarters)* (Vienna, 1994)

Dan Cameron

Why Curate?

Installation view of *Pierre et Gilles,*
New Museum, 2000–2001

The first question to ask someone who plans to set out making
exhibitions of contemporary art is, *Why curate?* The world is more
or less full of exhibitions, to misquote Douglas Huebler, so why add
to them? Why is it necessary for you in particular to cross the line
between a person who visits and perhaps thinks about exhibitions,
and someone who is compelled to produce them? Is it the knowledge
gained from delving into an artist's practice, or into an issue that is
best addressed by conceptualizing a visual project from a range of
artistic practice? Or is it more personal, based on your subjective
engagement with exhibitions as a form of public expression?
Whatever your reasons for doing so, you must be clear about why
you curate, then analyze and challenge those motives on a regular
basis, and, whenever possible, expand on them.

The curator is a kind of medium for artists, so one of the first
rules of curatorship is, *The artist must be happy.* It's only logical:
artists, who specialize in a visual medium, really cannot be expected
to take your ideas seriously unless their spatial (or technological or
institutional) needs are addressed. You are not permitted to step back
and survey your work with satisfaction until the artists involved are
satisfied that their work is being presented to its greatest advantage.
This rule has another dimension: as someone who takes the fleeting

experience of an exhibition very seriously, your vocation also consists of turning your advocacy of artists' ideas into a public gesture. One of the reasons you became a curator in the first place is that you believe in the way artists think and work; now's your chance to prove it.

You must risk failure. They don't tell you this in curator school, but if you're really any good you're going to fall on your face a couple of times; it's endemic to the medium of exhibitions. A truly successful exhibition involves balancing a range of intricate variables, and it only takes a little extra pressure in one spot to cause the whole thing to topple. I say, Go for it. You never really know what you believe until your curatorial growing pains are hung out there for the whole world to examine, so why not strive for legibility first? The alternative is to have a long, safe career making boring exhibitions that never take the discourse anywhere it hasn't already been, and what's the pleasure in that?

You are also a kind of artist, so one of your fundamental challenges is to *create the space you want to occupy.* In other words, make sure the experience that you have when you leave the exhibition is what you were looking for. It's the same rule whether you strive for a certain quality of feeling, or want to drive an idea home, or if you began with a premise about the space itself. Sometimes much of the artwork in a show is strong, but the exhibition can still be lacking a sense of how the parts fit into the whole. Besides, if you can start at the beginning of your own exhibition, work your way through it, and get a clear sense of what you were going after, it's more likely that the viewer will be able to do the same.

Dan Cameron, born 1956, Utica, New York, U.S.
Current position: Senior curator, New Museum of Contemporary Art, New York. **Former position**: Freelance curator. **Selected exhibitions**: *Paul McCarthy* (2001, New Museum); *Cildo Meireles* (1999, New Museum); *David Wojnarowicz* (1998, New Museum); *Carolee Schneemann* (1996, New Museum); *Cocido y Crudo* (1994, Museo Nacional Centro de Arte Reina Sofía, Madrid). **Selected publications**: *Janine Antoni* (Stuttgart, 2000); *William Kentridge* (New York, 1999), *NY Art Now* (London, 1989)

Lynne Cooke

Memoranda (Three Quotations)

Installation view of *Richard Serra: Torqued Ellipses*, 1997–98

"One sits more comfortably on a color one likes."
—Verner Panton

"There is always a filter, a mediation, which inspires your work; not when you are looking out of the window but when, once you have closed it, you recollect what you saw outside. You cannot avoid your work being influenced by culture *and* perception."
—Giulio Paolini

"Prophecy is the most gratuitous form of error."
—George Eliot

Lynne Cooke

Current position: Curator, Dia Center for the Arts, New York. **Former positions** include lecturer, History of Art Department, University College, London University; visiting lecturer, Visual Arts Department, Syracuse University. **Selected exhibitions**: *Carnegie International* (co-curator, 1991, Pittsburgh, Pennsylvania); *Aperto*, in Venice *Biennale* (1986). **Selected publications**: *Roni Horn* (London, 2000); *Louise Bourgeois* (Madrid, 1999); *Douglas Gordon* (Hannover, 1998); *Andreas Gursky* (Düsseldorf, 1998); *Richard Serra* (New York, 1997); *Rebecca Horn* (Hannover, 1997); *Ann Hamilton* (New York, 1995); and *Gary Hill* (Paris, 1993)

María de Corral

My Own Shared Credo

Work by Mario Merz in *The '80s in the Collection of the Fundació "la Caixa,"* Estación Plaza de Armas, Seville, Spain, 1992

I would hope this brief commentary can be looked at not as words of advice from an "older" curator with long experience but rather as an attempt at sharing some thoughts and ideas.

For me, our profession is unthinkable without an abiding love and passion for art and tremendous respect for artists' work. Still, it cannot be a neutral calling, because every selection is in itself a stand, a thought, a staging, a composition. Constant vigilance is required to avoid entangling the definitions of curatorial practice and the roles inherent to curatorship with the concepts of authorship, authority, and power. Self-aggrandizement, using artists, meddling with the works—these must all be banished.

Projects are never carried out in the abstract, in a vacuum: we work for an institution, at a given venue, at a specific time. Unquestionably, we have to grapple with the constraints of our institution's operating criteria; but by the same token, through our work, we can leave our own imprint on our institution's image. Our exhibitions should be like a forum where we can forge opinions, make judgments, define positions.

Rejection of radically new, cutting-edge art by certain sectors of society should not be a concern. Ordinarily, attendance by the public is an endorsement not of the level of artistic attainment but rather of the institution's own prestige.

We are obliged to try to think in terms of impetus more than categories, to act as curators, not as historians.

Our purpose should be to kindle an awareness and a sensitivity toward creative processes, to understand that in many cases in today's art world there is more concern with the problems surrounding the act of art itself than with the actual materialization of art. Never before has the spectator played such a central role vis-à-vis artworks. Artistic discourse does not spring forth complete or finished; often, it serves more as a threshold to cross over than as a window for looking out.

For the art that we present to have meaning, it must be understood as a practice both aesthetic and ethical at the same time, to enable us, the artists, and the spectators to work and rework reality.

I believe that Alfred Barr's definition of the task of museums still rings true for all curators today: "The aware, ongoing, determined distinction of quality, as opposed to mediocrity."

María de Corral, born Madrid, Spain
Current position: Director, Contemporary Art Collection, Fundació "la Caixa," Barcelona. **Former positions** include director, Museo Nacional Centro de Arte Reina Sofía, Madrid; director of visual arts of Fundació "la Caixa." **Selected exhibitions**: *Guerrero- de Kooning: La Sabiduría del Color* (2001, Centro Guerrero, Granada, Spain); *Space as Project, Space as Reality*, in Pontevedra *Bienal*, Spain (2000); *Contemporánea* (2000, Santiago de Compostela, Spain); *Retrospective Exhibition of Helena Almeida* (2000, Centro Galego de Arte, Santiago de Compostela, Spain); *Los Anos Ochenta* (1998, Culturgest, Lisbon); *Painting for Themselves: Picasso, Miró, Guston, de Kooning—Late Works* (1996, Neues Museum Wesserburg, Bremen, Germany)

Bice Curiger

A Plea for Intellectual Speculation

Works by Erik Bulatov, Sarah Lucas,
Duane Hanson, Robert Gober, and
Ben Schonzeit in *Hypermental*,
Kunsthaus Zürich, 2000–2001

As an art historian, I always defined my work through my close rela-
tionship with artists. These relationships have provided me with a
basic motivation and focus. Artists continue to bring us in touch with
our contemporariness; or, to use loftier terms, they open new avenues
for a better understanding of art, life, and the world in general.

That is why monographic studies and single-artist exhibitions
continue to be important to me. I like to devote myself to focusing on
individual artists, comparing and analyzing their works, and to put
them in a historical context. In that way, I can try to communicate their
meaning to the public. Only when we know and understand a variety
of singular positions in a field characterized by constant change can we
obtain an overview and define our philosophical stance.

It is a great privilege to be able to participate in the making of art
history. Wouldn't we curators be served well with the kind of humility
with which Thomas Hirschhorn defines his artistic mission: "I want to
work in non-hierarchical terms, I do not want to intimidate"? But how
do we do that? Doesn't the role of the "boss" come naturally to curators
from institutions that reinforce them in this role? Today some more
thought needs to go into this subject.

It is indispensable that museums be staffed with people actively
involved in contemporary art. In this way, museums as carriers of mass

culture, which they have become, will not degenerate into mere production sites of kitsch for the educated bourgeoisie (where artwork eagerly objectified to death is reheated for the umpteenth time) and of reductionist didactics. How terrible if the basic artistic strengths, the powers of art to seduce us and get us to question what we "know," fall by the wayside! For this reason, the grand historical narrative must essentially be broken down by taking an approach to curating that embraces unconventional structures.

It is my privilege to work for a major European museum and to direct an art publication launched in the mid-1980s to meet a need for a slowed-down, in-depth discourse about art. It was and is our goal to invest the written contributions with dignity and even a certain appeal.

The path that eventually led me to a museum career started in the subcultural awakening of the 1970s, with exhibitions such as *Frauen sehen Frauen* (1975) and *Saus und Braus, Stadtkunst (Mayhem)* (1980). In these exhibitions, a group of people reacted collectively to the cultural and sociological conditions of the city of Zurich. It was a joyous movement full of unbridled anarchism. These small exhibitions enjoyed considerable acclaim because, for one thing, they were mounted in the elegant surroundings of a long established institution housed in a Baroque building in the heart of the old town—and not in an old factory.

All those who work for museums should be aware of the stereotypes these institutions inevitably generate. They should develop a courageous attitude, break with the past, take risks, and, above all, bring Joseph Beuys's ideas of "permanent discourse" to life. After all, artists are the first to fight cultural paralysis and often to recognize what is overlooked in society.

When I organized *Freie Sicht aufs Mittelmeer*, an overview of young Swiss artists at the Kunsthaus Zürich in 1998, I wondered how to avoid the paternalistic gesture of attempting to select the twenty "best" artists. We decided to invite as many artists—one hundred—as would fit in our exhibition space, including video artists. The venerable museum was to be challenged by an unusual influx of youthful dynamism, and young artists were to measure themselves against the quality of an artistic output of more than five hundred years ago. As if the city were

under siege, Fabrice Gygi obstructed the museum entrance with big, black, high-tech sand bags. Was this symbolic shield supposed to protect the inside from the outside, or vice versa?

The fact that many contemporary artists consciously choose a direct and accessible pictorial language dovetails with the interest of museums in attracting a wide range of visitors, from the well-informed art lover to the curious tourist. *Birth of the Cool: American Painting from Georgia O'Keeffe to Christopher Wool* (1997) was motivated by the desire to present a European view on this distinctly American mix of direct pictorial language and cultivated painterly discourse and to take a look back from today's standpoint, unfettered by orthodox modernist views. (It should be noted that Clement Greenberg was not translated into German until 1995!) Therefore, instead of opening the show with the heroic originator of American abstraction, Jackson Pollock, we started with the spacious, simultaneously abstract and figurative images of Georgia O'Keeffe.

In spite of the above-mentioned humility, a professional curatorial statement may take on a personal tone. Somebody stands up and offers food for thought. Why should we hide behind an institution, behind an anonymous technocratic routine or an objective theory that abuses art as illustration? Anyone committed to speculative, experimental thinking, to in-depth treatment of the past in combination with the stimulating inventiveness of contemporary art, must be prepared to risk the conservative criticism of taking a subjective stand.

 Bice Curiger, born 1948, Zurich, Switzerland
Current positions Curator, Kunsthaus Zurich; editor-in-chief, *Parkett*.
Selected exhibitions: *Hypermental: Rampant Reality 1950–2000, from Salvador Dali to Jeff Koons* (2000–01, Kunsthaus Zurich, traveling exhibition); *Birth of the Cool: American Painting from Georgia O'Keeffe to Christopher Wool* (1997, Deichtorhallen Hamburg, traveling exhibition); *Meret Oppenheim: Beyond the Teacup* (1996–97, co-curator, ICI traveling exhibition); *Saus und Braus, Stadtkunst (Mayhem)* (1980, Zurich). **Selected publications**: *Meret Oppenheim: Defiance in the Face of Freedom* (Zurich, 1982); *Sigmar Polke: Photographs* (Paris, 1971); "Sigmar Polke Back to Postmodernity," in *Liverpool University Press and Tate Gallery Liverpool* (1996)

Donna De Salvo

Notes on Curating

Works by Andrea Zittel, Gregory Crewdson, Marcel Duchamp, René Magritte, and others in *Staging Surrealism: A Succession of Collections 2*, Wexner Center, 1997

I remember a visit, as a child, to the Vatican Pavilion at the 1964 World's Fair in which Michelangelo's *Pietà* was on exhibit, flown in from Italy and plunked down behind glass at its site in New York's Flushing Meadows. You viewed it while standing still on a moving walkway, the kind now ubiquitous in many airports. Years later, in my first museum job, I had a very different encounter with a work of art when I had the task of examining Meret Oppenheim's *Object* (1936), a fur-lined teacup and saucer. I recall carefully recording the height, width, and depth of both cup and saucer. Holding the work in my hand, I also imagined what it might be like to sip some mad Surrealist brew from it.

As a curator, I have always tried to hold onto the stance of the spectator, peering from the outside in, while also conveying the thrill of the insider who gets to handle the fur-lined cup. In thinking about what I might tell a young curator of contemporary art, a number of ideas surfaced (in no particular order) that I hope will prove helpful. I must emphasize, no matter how obvious it sounds, that good curating

depends upon a bottomless passion and curiosity for looking and questioning; and the desire to communicate that excitement. That said, here are a few other thoughts:

• An exhibition is a discursive space. Each time an exhibition is staged, different narratives can be elicited, as in a play. At its best, an exhibition is a beginning, a catalyst for critical inquiry.

• Exhibitions and museums have histories. Learn them. Look at what artists look at and how they look at it. Marcel Duchamp's *Mile of String*, Frederick Kiesler's *Art of This Century*, Andy Warhol's *Raid the Icebox*, Fred Wilson's *Mining the Museum*, and Barbara Kruger's *Picturing Greatness* are installations that we can still learn from.

• Don't be afraid to take the known in an unknown direction or to pursue what others have dismissed or failed to confirm. Leave behind evidence of your process of discovery—your "trail of breadcrumbs." Some of your most interesting discoveries will be found in periods and artists that lie between what are regarded as the "great" moments, before things have been labeled. You have to look for these.

• Take your cues from the art, but don't forget to look at the world around you—in the studio, in the street—since you never know where you will find ideas for how to display the art that you're interested in showing.

• Talk to artists about their work, the work of other artists, and a lot of other things. The best conversations you can have with artists are not always about art. Curators can learn from artists and from the way they experience the world. The artist can also learn from the curator. The curatorial process is a working relationship.

- No institution, no matter how neutral its white walls, is ever neutral. Therefore, be conscious of what you inherit as a curator when you walk in the door; it is even more imposing to your public.

- We trade in ideals. Therefore, it is essential to never lose sight of the fine line we tread in performing the three principal tasks we face: advocating for artists and their art; communicating to an interested public; and confronting the reality of the institutions we work with.

- We work in a profession that offers few guarantees. So get yourself a good pension plan or invest as much of your earnings as possible while you are still young, as soon as possible.

Donna De Salvo, born Newark, New Jersey, U.S.
Current position: Senior curator, Tate Modern, London. **Former positions** include curator-at-large, Wexner Center for the Arts, Columbus, Ohio; curator, Dia Art Foundation, New York. **Selected exhibitions**: *Century City: Art & Culture in the Modern Metropolis* (2001, Tate); *Ray Johnson: Correspondences* (1999, Wexner Center, traveling exhibition); *Hand-Painted Pop: American Art in Transition 1955–1962* (1992, Museum of Contemporary Art, Los Angeles, traveling exhibition); *Success Is a Job in New York: The Early Art and Business of Andy Warhol* (1989, Grey Art Gallery, New York). **Selected publications**: *Ray Johnson: Correspondences* (Paris and London, 1999) *Past Imperfect: A Museum Looks at Itself* (Southampton, New York, 1992)

Steve Dietz

Curating New Media

Work by Victoria Vesna, in collaboration with Gerald de Jong and David Beaudry, in *Telematic Connections: The Virtual Embrace,* San Francisco Art Institute, 2001

In the film *Sleeper,* the past from which the character played by Woody Allen awakens is just as inscrutable to his captors as their futuristic society is unbelievable to him. They have lost the context for the most "obvious" of artifacts, whether a portrait of Richard Nixon or a household vacuum cleaner. At some almost unimaginable point in the future, a few years from now, a young curator of contemporary art may find the issues of the present day regarding what is sometimes referred to as "new media" equally opaque.

What follows are answers to the five most frequently asked questions about curating new media, with both questions and answers based on a search of 32 billion pages on the Internet. The answers are formulated using new and improved collaborative filtering algorithms, developed by a consortium of acronyms, which have increased response accuracy by two orders of magnitude.

What is new media?
In 1839, it was photography. In 1895, it was motion pictures. In 1906, it was radio. In 1939, television. 1965, video. 1970s, computer graphics. 1980s, computer animation. 1994, the World Wide Web. 1995, Mosaic.

Then Quicktime, Shockwave, Real, Flash. 1999 was the year of the database; 2000, transgenic art; 2001, PDAs. In 2002, it will be telepathy.

There are two converging trend lines regarding new media. One is the contraction of the periodicity of the introduction of new media. The other is increasing specificity as the present is approached. This is known as marketing and is better diagnosed as myopic conflation of technology (materials) and medium. There is no such thing as Palm Pilot art.

Is there such a thing as new-media art?
Yes, there is art that is made out of new materials—e.g., Dan Flavin's neon sculptures or John Maeda's work using Palm Pilots.

You know what I mean.

Computation is an important and real threshold. It is the ability for a machine to understand and act upon instructions like a language. In this regard, computation is a process not found anywhere else (except in humans), which makes it more like a medium, such as photography, than a practice, such as Conceptual art. To the extent that computation underlies the emergence of "new media," it is a vast territory for exploration and experimentation and not just another name for the new, the contemporary, the living.

What about the Internet?
Whether as mail art or royalty, networks are not a new concept. The Internet is a new instantiation of the network, which relies on computation. As such, Net art is more akin to a practice like Conceptual art than a medium like photography.

Okay, then what about the virtual? Is Net art different because it is virtual—i.e., protocol-based?
One line of argument is that there is a virtual (and interactive) encounter with every compelling work of art in one's mind. This doesn't obviate that something has to trigger that encounter, whether

it is Net art or painting. An extension of that argument is that a Sol LeWitt drawing is "just" an algorithm that gets executed—usually in a physical format. To view one of LeWitt's drawings on a computer screen is not the real thing. Likewise, to print out a Net art "page" on paper is not the real thing. There is a difference that makes a difference. Pierre Levy points out that the antonym of "virtual" is not "real"—it is "actual." Both the virtual and the physical are real, but they are not necessarily the same.

But is it art?
Yes.

And?
[Program gets stuck in recursive loop circling around solipsistic definitions of art—"It doesn't *look* like (real) art"—and issues of personal taste—"I haven't seen any Net art that *moved* me"— which are independent of new media per se.]

But just a minute. Isn't that precisely the role of the curator—to identify the best and the brightest?
No.

Then why do we need curators?
It's an ecology thing. We need a diverse culture. I don't know why you do or don't need curators, but I curate to learn something, to research. As often as not, what I find out modifies what I thought I knew before. This is time-based truth. Hopefully, my point of view is of use to someone else, at least for a while.

 I am also committed to a practice that is much more about building infrastructure and creating a hospitable (and critical) environment for new-media art to take root than it is about a garden hothouse to showcase and refine an increasingly hybridized strain of art. Presumably, the needs of this environment will change over time as

well. And I will enjoy checking out (online) how the new generation of curators is trying to keep up with the artists, while I tend my showy orchids in the long winters of Minnesota.

Steve Dietz, born 1958, Minneapolis, Minnesota, U.S.
Current position: Director, new-media initiatives, Walker Art Center, Minneapolis. **Former positions** include chief of new-media initiatives and publications, National Museum of American Art, Smithsonian Institution, Washington, D.C. **Selected exhibitions**: *Telematic Connections: The Virtual Embrace* (2001–03, ICI traveling exhibition); *Open Source Lounge: Outsourcing Creativity—Audience as Artist* (2000, Athens, Greece); *Art Entertainment Network* (co-curator, 2000, Walker Art Center); *Shock of the View: Artists, Audiences and Museums in the Digital Age* (1998, Walker Art Center); *Beyond Interface: Net Art and Art on the Net* (1998, Toronto, Canada). **Selected publications**: "The Millennial Museum," in *Spectra* (2000); *CyberMuseology: Taking the Museum to the Net/Bringing Digital Media to the Museum* (1999); *Curating (on) the Web* (1998)

David Elliott

Making Sense of Things

Works by Jouko Lehtola and Bjarne Melgaard in *Organizing Freedom*, 2000

It was as a way of making some sense of things—making exhibitions, that is. I made my first in 1970 in Durham—an old university town in the northeast of England—when I was twenty-one.

All historians are story tellers and autobiographers—and, after a brief, unsuccessful stint working in a theater, I went on to study history. The stage I was on was a little larger now, and I became engaged in the drama of visual representation, culture, and ideology. It was the end of the 1960s, a wonderfully oedipal time, and my anger, and that of my generation, became focused on the fragile ethical power and quality of art and its relation to authority. My radicalism was rooted in that of Beckett, Brecht, Camus, and Eisenstein.

And so I looked back—to the object lessons of the early twentieth century, as well as to the feelings of alienation and displacement I could recognize in myself. It started with Germany—then Britain's traditional enemy—and, as a postwar child, I felt strongly aware that the terrible experiment of Hitler's National Socialism was some kind of object lesson for modernity. The carefully planned utopian dream that was then still driving us all forward had the probability of corruption inscribed at its heart.

Leicester, the industrial city in the middle of England where I grew up, had taken in many refugees in the war. By the 1960s,

53

through gifts and bequests, its art museum was one of the few places—
if not the only one—in Britain where you could see German
Expressionist art. It had made a strong impression on me, but even
stronger had seemed the small, almost gemlike mask heads—gouaches—
on the wall of a friend's dining room. To me, these intimate, even
domestic, objects seemed exotic: there were no paintings on our walls
at home; the images were primitive, even savage; my friend's family
had come from Czechoslovakia and Germany, fleeing Hitler. And they
flew into my mind years later, when, as a student, I was thinking about
power, oppression, and imagery.

But why make an exhibition? The answer was simple: one of my
friends, who was also friends with an artist whose father had a well-
placed contact, organized one from Edward James's collection of
Surrealist paintings the year before. If he could do it, I could too. I was
also fascinated by what was then a virtually unacknowledged history of
culture (the Brits thought that art and ideology did not mix; such ideas
had largely been introduced by the refugees in the 1930s) as well as by
the almost secret immigrant communities and the art they had brought
with them. The exhibition became a cultural festival, although God
knows what it was celebrating. *Germany in Ferment: Art and Society
1900–1932* became an agglomeration of exhibitions and programs of
art, design, photography, film, and theater—and a personal testimony
to both the power and impotence of art and individual autonomy.

I now know that this was the first step on a path of research about
the relationship between life, art, power, and ideology on which I am
still engaged. Over the past thirty years, the words, concepts, and even
language have changed, more than anyone could ever have imagined.
The global changes of the 1980s and 1990s—unparalleled in their scale,
intellectually, ideologically, and politically, since the end of the eighteenth
century—have bidden farewell to the simple polarities of "left" and "right"
and conflicting superpowers. With the end of apartheid in South Africa,
the post-colonial settlement throughout the world has also changed
irrevocably, although we do not yet know what the future will bring.
Power now wears a different face. But when you put all this together,
it still seems to me that the production of autonomous, "good" art is a

kind of litmus test for basic freedoms in civil society; and when art is limited or threatened, there are real problems to be faced. This is because art as a field of production runs parallel to life, is of life (and may even be about life), but is not the same thing as life. As such, it is one of the few relatively "free" activities we are able to sustain.

Three of my recent exhibitions and research projects have looked at these issues in different ways. *Wounds: Between Democracy and Redemption in Contemporary Art* (1998) examined the work of seventy European and American artists from the 1960s to the present from the point of view of how art is often created at points of social and personal fragmentation, dislocation, friction, and even pain. *After the Wall: Art and Culture in Post-Communist Europe* (1999) showed the work of one hundred and fifty artists from central and eastern Europe. *Organizing Freedom: Nordic Art of the '90s* (2000) took the words of a song by Björk to cast light on the new generation of artists in northern Europe (*"Thought I could organise freedom, how Scandinavian of me"*). Organizing freedom could be regarded as the task of artists (and curators) everywhere.

David Elliott, born 1949, Manchester, England
Current position: Director, Moderna Museet, Stockholm, Sweden.
Former positions include director, Museum of Modern Art, Oxford, England; honorary president of CIMAM (International Council of Museums of Modern Art). **Selected exhibitions**: *Organizing Freedom. Nordic Art of the '90s* (2000, Moderna Museet); *After the Wall: Art and Culture in Post-Communist Europe* (Co-curator, 1999, Moderna Museet); *Art from South Africa* (1990, Museum of Modern Art, Oxford); *Alexander Rodchenko* (1979, Museum of Modern Art, Oxford). **Selected publications**: *Wounds: Between Democracy and Redemption in Contemporary Art* (Stockholm, 1998); *Photography in Russia, 1840–1940* (London, 1992); *Waiting for Muzot* (Amsterdam, 1991); *New Worlds: Art and Society in Russia, 1900–1937* (Stockholm, 1986)

Trevor Fairbrother

Going Forward, Looking Back

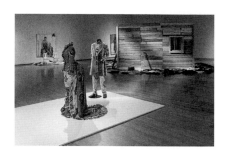

Works by Whitfield Lovell and
Yinka Shonibare in 2000 $^1/_2$:
Going Forward, Looking Back, 2000

Since the 1960s, there has been dramatic growth in the thinking
about the forms, functions, sites, and life spans of exhibitions. It is
not surprising to say that nowadays they can be anything, from virtual
experiences to modest or monumental presentations that happen
only once in a specific place. We curators have artists to thank for the
radical expansion of our potentialities. Today's exhibitions are diverse
because we have learned to serve a burgeoning multiplicity of artistic
expressions. Even so, the prevalence of run-of-the-mill projects firmly
supports the argument that it takes a special creative ability to make
a memorable exhibition.

Every kind of exhibition appeals to me. I've not tried them all yet,
but I salute the following: the buttoned-down, every-known-edition
scholarly effort; the no-labels, no-obvious-thesis display of work that
seems vibrantly of the moment; the spiffy or bookish trotting out
of blue-chip items; the conglomeration of works by disparate artists
chosen from the hundreds who submitted slides; the theme show
that carries new thoughts on seemingly familiar "schools" or topics;
the permanent collection project that gets things out of the storerooms
if only to confirm prevailing verdicts; the check-the-pulse examination
of a single medium; the politically correct affair with teams of com-
munity advisers, academic collaborators, and institutional partners.

Whatever it is, make a strong delivery that lays it out and still keeps 'em guessing.

When preparing an exhibition, I never think in terms of a single goal. Rather, I pray that it will encompass many conditions and have more presence than I could imagine. From the moment of coming up with the initial idea until the completion of the installation, I seek an experience unlike any other, an original instance of beauty and visual communication, a trigger for insight and learning. I envision the exhibition taking visitors out of themselves and sowing the seeds of new awareness.

Soon it will be just another show that does or does not get "good" reviews and visitation; therefore, the dreaming and striving are crucial. They nurture the product's vitality. I personally like to add the risk of making some aspects of the checklist or installation instinctive and quirky. Hunches and gambles keep me attentive throughout the process. Even if I come to regret them, I value the kind of rigor they engender along the way.

The installation is the most exciting part for me. As necessary as it is to have a well-developed plan, I still commence with a rousing sense of not knowing exactly where I'm headed. It persists until I'm convinced that all the works are in some kind of dialogue. I don't mind whether they harmonize, butt heads, or maintain a respectful distance, so long as the presentation allows them to look and talk like an ensemble that can touch viewers.

I learn so much from the people I work with during the installation: designers, art handlers, curators, conservators, and, of course, artists. The wonderment I sometimes experience when artists participate has changed me and deepened my appreciation of the kinds of creativity that can make an exhibition special. (Thank you Louise Lawler, Group Material, and Richard "There will be some derangement" Artschwager.)

Curators now participate in many more professional encounters when making exhibitions. The players include: fund-raisers cultivating sponsors and servicing clients; gung-ho content-providers for docents, statements and core values; troopers upholding local artists; educators pioneering "cool" ways for children to interact in the gallery; bigwigs

patrolling the bottom line or promoting newfangled management ideas; members' groups lobbying for their own special interest; marketing strategists massaging entertainment potential and family angles; and assorted wild cards worrying about "quality" or "things people want to see." Respect these colleagues while teaching them the contingencies of curatorial practice. In this crowded field, it is even harder to make singular exhibitions: many of the issues are gray, compromises abound, and new challenges keep coming. But the chance to foster delight and knowledge remains an honor.

Trevor Fairbrother, born 1951, U.K.
Current position: Independent scholar and curator, Boston.
Former positions include deputy director of art, Seattle Art Museum; curator of contemporary art, Museum of Fine Arts (MFA), Boston; associate curator of American paintings, Museum of Fine Arts, Boston. **Selected exhibitions**: *2000 ¹/₂: Going Forward, Looking Back* (2000, Seattle Art Museum); *Cindy Sherman: Allegories* (1998, Seattle Art Museum); *Night and the City: Homage to Film Noir* (1997, Seattle Art Museum); *The Label Show* (1994, MFA, Boston); *Beuys and Warhol: The Artist as Shaman and Star* (1991, MFA, Boston). **Selected publications**: *John Singer Sargent: The Sensualist* (Seattle, 2000); *The Virginia and Bagley Wright Collection* (Seattle, 1999); *Brice Marden* (Boston, 1991)

Jane Farver

Reflections

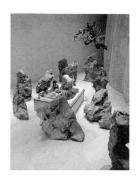

Work by Cai Guo-Qiang in
Cultural Melting Bath, 1997

My first advice to curators of contemporary art: always return to
that art which involuntarily becomes part of your visual and psychic
vocabulary—work that you simply cannot deny. Remember that
art doesn't actually mean anything; rather, it is something an artist
means to say. That message must be discovered in the art itself.
Listening to what the artist actually says about the work is helpful,
but not the same thing, whereas listening to what artists say about
other artists' works is very helpful.

Exhibitions are like conversations. They begin with the privileged
conversation a curator has with the work in the artist's studio, and
it is the curator's job to transmit the studio experience to the viewer.
That privilege should be respected. It is dishonest to use an artist's
work to illustrate a curatorial thesis that is irreconcilable with the
work, which is the equivalent of quoting the artist out of context.
I have never felt I had anything to say that was as interesting or as
important as what the art(ist) had to say—and I do not think there
are all that many curators or critics who do.

A curator must choose the participants in the exhibition/conversa-
tion carefully, but be willing to take risks. It should be neither a
shouting match nor a polite droning. As moderator of the "discussion,"
the curator must be able to elicit passionate, even extreme, opinions,

yet keep the dialogue lucid and well paced even if the art(ist) requires the aid of a translator. It doesn't matter in which language an idea is first expressed, as long as it is a good one. The audience will remember the idea and not the translator.

At all costs, resist the temptation to go with guaranteed successes. Take your exhibition down unexplored paths. The outcome should not be known in advance. It is the curator's job to share access to resources and to push the limits of what gets exhibited. Because I came to curatorial practice through the alternative space movement of the 1970s and 1980s, my primary concern has been to include the unincluded in the dialogue.

Whenever possible, create situations that allow for the creation of new work. Increasingly in such situations, curators are partners in the production (but not the creation) of an artist's work. Thus, shopping for an artist's project should not be confused with making it.

Remember that exhibitions are not made just by you. Recognize and respect the contributions of the members of your exhibition team. Credit everyone who helped you.

Also remember that exhibitions are not just for you or the art world but for a general audience. Gauging just who makes up the audience is one of the curator's most difficult duties. In deciding what to show, it is important for curators to look for work that is relevant to them personally but also of local as well as national and/or international interest. Curators have the delicate task of helping the audience to understand the circumstances under which a work has evolved without using the work as an illustration in a history lecture. Be aware, though, that many critics have little knowledge of the histories of other parts of the world, let alone knowledge of important modernist, conceptual, and post-modernist art histories that have transpired elsewhere. As a result, critics may tend to criticize some international modern and contemporary artists as opportunistic, or to dismiss their works as derivative of works with which they are familiar. This doesn't matter.

Few institutions have been willing to organize exhibitions to fill in the gaps, but this is beginning to change. Good work will survive the

dislocation of being shown out of its original context (whether geographic or temporal). Moreover, artists long ignored are finally being written into mainstream art history—a curatorial reform that has come about because the importance of those artists' work could not be denied.

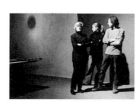 **Jane Farver**, born Bellefonte, Pennsylvania, U.S. **Current position**: Director, M.I.T. List Visual Arts Center, Cambridge, Massachusetts. **Former positions** include director of exhibitions, Queens Museum of Art, New York; director, Lehman College Art Gallery, CUNY, Bronx, New York. **Selected exhibitions**: *Global Conceptualism: Points of Origin, 1950s–1980s* (co-curator, 1999, Queens Museum, traveling exhibition); *Out of India: Contemporary Art of the South Asian Diaspora* (1997–98, Queens Museum); *Cai Guo-Qiang, Cultural Melting Bath: Projects for the 20th Century* (1997, Queens Museum); *Across the Pacific: Contemporary Korean and Korean American Art* (1993–94, Queens Museum); *Adrian Piper: Reflections, 1967–1987* (1987, Queens Museum, traveling exhibition). **Selected publications**: *Luca Buvoli: Flying—Practical Training for Beginners* (2000); *Global Conceptualism: Points of Origin, 1950s–1980s* (New York, 1999); *Yukinori Yanagi: Project Article 9* (1995)

Robert Fleck

A Visual Medium

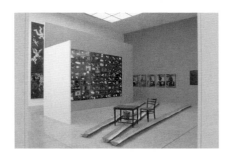

Installation view of *Centennial Exhibition of the Vienna Secession,* 1998

In 1980, while I was writing my first book (about art in Austria since 1945), I had a meeting with Werner Hofmann, who was born in Vienna and was then one of the most influential art historians in Europe. During this meeting, Mr. Hofmann said, "I have to tell you, since I am very engaged in writing about art, that when you organize an exhibition, you feel much more satisfaction than with writing a book. When you see all these artworks together, simultaneously, you experience much more about what art is or could be, about what could be your vision of art, than you do with any written text."

At the time, I was astonished at such an idea. I have always felt that having a book published would be the realization of an ultimate goal. Only when I myself had the privilege of organizing a big group exhibition (*Weltpunkt Wien*), first in 1982 in Austria then in 1985 in France, did I experience what Hofmann had described. Since that time, I have gathered three very basic ideas about exhibitions and curators.

First, there are two kinds of exhibition curators. Some curators seem to be born organizers of exhibitions. When they enter a new

space or discover a new artist, they immediately think in terms of a possible exhibition. At the opposite pole are curators who tend to channel their responses to art through language, text, and theory. They are writers, above all, even if sometimes they organize very interesting exhibitions. For any curator or art critic, it is very important to know whether he or she is naturally a writer-critic or an exhibition organizer. An exhibition organized by a writer-critic is often an argument in visual form, articulated through the display of particular artworks and the relations among them. "Natural" exhibition organizers treat the artworks as pure visual facts, establishing direct relationships among the works, the artists, and the viewers. Both kinds of exhibitions can have the same impact, but they will be different by nature.

Second, the contemporary art exhibition has become a new medium, joining the other new art mediums invented during the twentieth century. However, the exhibition is by definition a visual medium. Even an exhibition of sound art can only be successful if its curator considers the exhibition in itself, and the sound pieces as visual phenomena beyond the range of visual perception. Considering the exhibition as a visual medium does not negate its potential (and responsibility) for conveying thought and meaning. But an exhibition has nothing to do with language or discourse (this was the point of view of Gilles Deleuze, for instance, regarding painting or film). Being a visual medium, the exhibition often has to do with thought. Its enormous energy comes from the fact that this thought is visual, direct, and not mediated by language (and certainly not by any particular language).

Finally, I believe that a curator is not an artist. There should be no confusion on this point. A curator is somebody who visits artists, talks with them, promotes them (if convinced of their talent and potential), etc. A curator is a facilitator who helps the artworks to become adequately visible (which often means production). The curator should never be considered a "meta-artist," merely an assistant whose existence is legitimized by the artists and the artworks he or

she is engaged with. What a curator can offer is a special understanding about art, or, at least, about some particular artworks, and through them, an interesting point of view.

Robert Fleck, born 1957, Vienna, Austria
Current position: Independent curator. **Former positions** include federal curator in Austria; director of studies for the post-graduate program of the Visual Art School in Nantes, France. **Selected exhibitions**: *Le Lieu Unique,* (2000, Visual Art School, Nantes); *Prodigé, Espace Paul Ricard,* (2000, Paris); *Centennial Exhibition of the Vienna Secession* (1998, Vienna); *Manifesta 2* (co-curator, 1998, Luxembourg); *Spielhölle: Aesthetics and Violence* (1992–93, Frankfurt/Main, Graz, Paris); *Weltpunkt Wien* (1985, Strasbourg and Vienna). **Selected publications**: *Public Art in France* (Paris, 1996); *Kunst in Oesterreich,* (Cologne, 1995); *Wittgenstein's Sculpture* (Klagenfurt, 1994); *Can Austria Survive the Year 1994?* (Vienna, 1991); *Artists in the Revolutions of 1848* (Vienna, 1991); *Weltpunkt Wien* (Vienna and Munich, 1985); *Avantgarde in Wien* (Vienna and Munch, 1982)

Richard Flood

Negatives to Remember

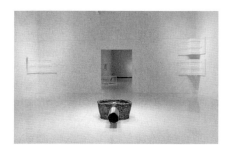

Installation view of *Robert Gober:*
Sculpture + Drawing, 1999

1. I am not the artist; I am the curator.
2. I am not the artist's significant other.
3. I am not the artist's agent.
4. I am not the artist's therapist.
5. I am not the artist's spiritual advisor.
6. I am not the artist's spokesperson (unless designated as such by the artist within the context of an exhibition's realization).
7. I am not doing the artist a favor by curating an exhibition of the artist's work; neither is my institution.
8. I am not owed anything by the artist in return for curating an exhibition; neither is my institution or its trustees.
9. I am not responsible for the success of an exhibition; the artist is.
10. I am not responsible for the failure of an exhibition; that is the price of being an artist.

The Regional Dilemma:

My institution's exhibitions are
1. never going to be reviewed by a national publication (daily or weekly) unless one of their critics is attending a class reunion, visiting family, on a book tour, or in detox (a Minnesota specialty).

2. never going to be reviewed by a national or international publication (monthly) unless I identify and promote the regional talent to write those reviews.

3. never going to make year-end, top-ten lists in *The New York Times* or *Artforum* because the lists are compiled by people who live in New York or—to be fair to *Artforum*—Los Angeles or London.

4. never going to receive the press attention they deserve because the press is obviously regional and our exhibitions are not.

5. never going to be credited to any institution other than the ones hosting them while they are on tour, which means that if an exhibition I organize is picked for a year-end, top-ten list, it will be because it was seen by a tastemaker in New York, Los Angeles, or London.

The Regional Privilege:
My institution's exhibitions are open to an audience and press who don't already know what they think about what they are about to see.

Richard Flood, born 1943, Philadelphia, Pennsylvania, U.S. **Current position**: Chief curator, Walker Art Center, Minneapolis, Minnesota. **Selected exhibitions**: *Robert Gober: Sculpture + Drawing* (1999, Walker Art Center); *Matthew Barney, Cremaster 2: The Drones' Exposition* (1999, Walker Art Center); *No Place (Like Home)* (1997, Walker Art Center); *"Brilliant!" New Art from London* (Walker Art Center,1996); *Sigmar Polke: Illumination* (1995, Walker Art Center)

Dana Friis-Hansen

Notes to a Young Curator

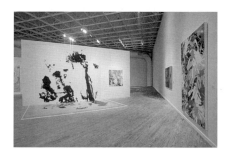

Works by Ingrid Calame, Polly
Apfelbaum, Beatriz Milhazes, and
Aaron Parazette in *Abstract Painting,
Once Removed*, 1998

Think of curating an exhibition as a series of interrelated and overlapping steps, which include—but are not limited to—research, thematic conceptualization, selection, contextualization, strategic arrangement, and interpretation. Multi-tasking is required for this job.

Begin with the artwork, then the artist. Study an object and try to understand where it fits within the artist's oeuvre, how it relates to the work of the artist's peers, and its historical context. Think of what it might convey outside the art gallery, too; the best work gains strength outside of protective custody. Get to know the artist factually and instinctually—by studying past works; reading as many reviews, interviews, or artist's statements as you can find; and, when possible, visiting the studio. Try to meet at least twice: once to look at the work, and a second time to have a more thorough discussion and delve deeper into key issues.

Individual works are building blocks that must fit together to create a shaped, focused experience of an exhibition for the visitor. The goal should be a sensual, stimulating, richly layered, multifaceted experience. A great exhibition is like a seven-course meal with good wine and fascinating conversation, not a stew in which many ingredients have been tossed together and boiled until each is indistinguishable from the whole.

Resourcefulness is required. Of course, you will not get every loan you request; your budget will not cover all "necessities" to fulfill your ideal plan; and the gallery will always be too small, the ceilings too low, or the doors in the wrong place—but here's your chance for creative problem-solving. In my experience, installing the show is both the best and worst part of the process, as this is where the imagined exhibition and the real objects come together, and the gaps between the two must be dealt with, using creativity, thrift, and timeliness.

A curator serves as an interpretive bridge. For every exhibition you should write a text, whether it is a short introductory wall text or a photocopied brochure or a more scholarly catalogue that documents the show. And gallery talks by the curator are vital ways to communicate our ideas and enthusiasm to those who are eager to learn more. Writing and public speaking should be a regular part of the curator's routine, and practice brings improvement. Read and re-read essays by the curators whose ideas most excite you; find colleagues who can read the preliminary drafts of your text or listen as you practice your talk to get candid criticism; invite friends to your talks and get them to provide feedback. Take as much care with your language about art as the artists do with their materials.

When presenting international art, the cultural context within which an artist works must be handled sensitively. I've learned too many times how a local community projects expectations onto any foreign art set in front of them. A curator working across borders must have a solid understanding and experience of both cultures, so that he or she can work both with and against stereotypes to enable the art and the artist to communicate most clearly. Including a voice indigenous to the region being presented, such as an interview with the artist or a text by a curator from that region, can provide vital cultural context. Too often, non-Western art is exoticized and sensationalized well beyond its basic, direct essences, and its home-grown resonances are lost in the spectacle of difference.

Just as art cannot be understood if separated from the context in which it is made, so, too, must the practice of curating take into account the physical, temporal, institutional, and community frame-

work in which one creates and shows an exhibition. The viewer is also part of the context. Curating cannot exist within a vacuum, and most of us work within institutions that serve various constituencies. One's audience might be considered as a series of concentric circles, the innermost circle consisting of those people most connected to the organization (such as colleagues and trustees), and, radiating outward, artists and regular art aficionados, then occasional visitors, and finally those who have never entered the gallery before. Each must be welcomed, but served in different ways by the various (visible and invisible) aspects of the exhibition's organization and presentation.

Curating is a daunting job to start with, and as we rise in the ranks we are expected to provide inspiring scholarly leadership and to offer aesthetic analyses instantly, while gracefully juggling myriad administrative duties. Savor the true challenge of this calling, which is to set the stage for transformative art experiences in the creative ways we bring art and ideas before the public.

Dana Friis-Hansen, born 1961, Worcester, Massachusetts, U.S.
Current position: Chief curator, Austin Museum of Art, Texas.
Former positions include senior curator, Contemporary Arts Museum, Houston, Texas; associate curator, Nanjo and Associates, Tokyo, Japan.
Selected exhibitions: *Takashi Murakami: The Meaning of the Nonsense of the Meaning* (co-curator, 1999, Center for Curatorial Studies, Bard College, Annandale-on-Hudson, New York); *Abstract Painting, Once Removed* (1998, Contemporary Arts Museum, Houston); *LA: Hot and Cool* (1998, M.I.T. List Visual Arts Center, Cambridge, Massachusetts); *TransCulture*, in Venice *Biennale* (co-curator, 1995). **Selected publications**: "Nan Goldin: The Party's Over," *Parkett*, no. 58; "Adrift in the Pacific: Filipinos in the Asian Contemporary Art Scene," in *At Home and Abroad: 20 Filipino Artists* (San Francisco, 1998)

Gary Garrels

Thoughts on Exhibitions

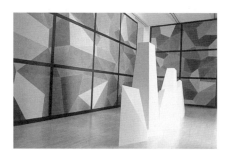

Installation view of *Sol LeWitt: A Retrospective*, San Francisco MOMA, 2000

There are countless works of art, artists, and ideas about art from which an exhibition might be organized, and there are usually numerous preconceived conclusions that affect a curator's choices. For me, being a curator is constantly to test my preconceptions and my thinking in what I hope may be a parallel process to the work of an artist.

This is a physical as much as a conceptual process. Art remains situational and physically obdurate. There is no substitute for moving from place to place and constantly looking. In this way, experience and information are layered, impressions are tested. I'm always working to keep my eyes and mind open, reconsidering, remembering, finding the things that remain alive to me through time and experience.

Out of this constant process, projects emerge. It becomes evident to me that an idea, an artist, an object, or some group of objects are ones to which I want to return. Some projects take on a specific and concise character; others prove to be daunting in scale. Some may be worked on quickly; others may unfold over years. Whenever I embark on organizing an exhibition, it is because I want to be closer to a certain artist and/or specific objects, to work with them, learn from them. In turn, I think about what other people might gain from

what I would do, an audience that includes not only friends and peers but an unknown public.

Each exhibition is a complete production, entailing everything from the overall concept to the most utilitarian detail. The selection and presentation of work sits in front of me at every stage of development. Organizing an exhibition is very different from writing an article or book. Yet, it is not only the physical situation of objects or spaces that I keep in mind, but also the social and intellectual frame around them. The practical issues are no less fundamental: the budget and the character and commitment of the team of people who are involved. Each aspect inflects the others and the whole. The success of an exhibition is attributable not to its great expense or scale, but to the integration of all the following concerns: ensuring that it is well executed, physically precise, and visually engaging, and grounded in a larger frame of cultural, social, political, historical, and philosophical issues.

Gary Garrels, born 1951, Mt. Pleasant, Iowa, U.S. **Current position**: Chief curator of drawings and curator of painting and sculpture, Museum of Modern Art, New York. **Former positions** include chief curator and curator of painting and sculpture, San Francisco Museum of Modern Art; senior curator, Walker Art Center, Minneapolis; director of programs, Dia Center for the Arts, New York. **Selected exhibitions**: *Sol LeWitt: A Retrospective* (2000, San Francisco MOMA, traveling exhibition); *Jasper Johns: New Paintings and Works on Paper* (1999, San Francisco MOMA); *Katharina Fritsch* (1996–97, San Francisco MOMA); *Willem de Kooning: The Late Paintings, the 1980s* (1995–96, San Francisco MOMA); *Photography in Contemporary German Art: 1960 to the Present* (1992, Walker Art Center). **Selected publications**: Essays in catalogues for the exhibitions listed above

Thelma Golden

Mama Said . . .

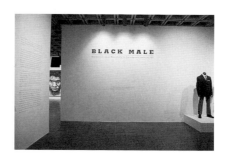

Works by Robert Arneson and
Fred Wilson in *Black Male:
Representations of Masculinity
in Contemporary Art*, Whitney
Museum, 1994–95

The only advice that I can offer a young curator is the advice given
to me by my mother. It is not curatorial advice exactly (although my
mother has been known to offer that), but it applies to the challenge
of trying to form and conceptualize one's curatorial practice. My
mother has a lot of sayings, which she says as if she made them up,
even though she did not. One of these sayings is, "You better get
while the getting is good." She never allowed slang, black English or
what is now called ebonics to be spoken, but would occasionally lapse
into the West Indian patois of her upbringing for comic effect. But
this particular saying, spoken with the appropriate inflection and
attitude, was an ominous warning. She often said it to my brother
and me when we were little. Many times, when she would offer us a
cookie or a Popsicle, we responded with something like, "I'll have it
when *Good Times* is over." (We couldn't eat in the bedroom, which is
where the t.v. was—an amazing rule, I now realize since we were
allowed to watch t.v. but not eat at the same time. In retrospect,
watching t.v. seems far worse than what she perceived as the ultimate
in sloth, which was crumbs in the bed.) Her response would usually
be, "You better get while the getting is good." Today, as adults, my
brother and I have rationalized this aspect of my mother's behavior
as being the result of her fatalistic, raised-in-a-large-family-during-the-

Depression attitude. Her thought was, If you want the cookie, you better have it now because there might not be another cookie later. This might be the last cookie—ever. Our own attitude was that there was always another cookie. And if not, we could go to the store and buy more. And if the store was out of them, daddy could pile us into his big gas-guzzling car and drive us to another store. To us, the world was full of cookies.

What I have learned is that my mother's attitude (as much as it drove my brother and me insane) is not entirely wrong. Or rather, I have learned that perhaps the most important thing is to seize every opportunity as if it is the last one. In the early 1990s, other curators and artists of color and I would joke about the fact that we thought we should do as much work as we could before we were no longer in fashion. It was a conversation of intense sarcasm, but always one tinged with the reality of the historic legacy of moments of hyper-representation and moments of gross exclusion. Being familiar with that history, we knew that we had to work hard while "the getting was good" because we understood that a moment might come when it would no longer be.

So this is a long way of saying, "Exist in your curatorial practice as if there isn't another cookie." If someone said, "You can only do one more exhibition/essay/project," what would it be? My advice is, do it now, whatever it is. Don't put it off for later. Take risks, every day. Work in the moment. Do it now. Do it fully. Do it well.

1. Take risks, every day.
2. Be an active co-conspirator with artists.
3. It is not as important where you work but who you work for.
4. Take one job in a place where you never have to think about money.
5. Take another job in a place where you always have to think about money.
6. Acknowledge the fact that you now have more than one job.

7. Choose one amazing curator who is no longer alive and study his or her work carefully.

8. Choose one inspiring curator who is currently working and ask him or her everything—and then tell it to someone else.

9. Do not, under any circumstances, read reviews of any exhibition you are involved in, until at least two years after it was done.

10. Become familiar with First Amendment law.

11. Become familiar with contract law.

12. Become very familiar with employment law.

13. Embrace the inevitable administrative tasks connected with any curatorial job and approach them as creatively as you would the making of an exhibition.

14. When strategically necessary, think like a museum director (but don't act like one).

15. When intellectually necessary, think like an artist (but realize you can never really be one, unless of course you already are).

16. Know that the institution will outlive you.

17. And with that in mind, strive to leave an indelible mark.

Thelma Golden, born Queens, New York City, U.S.
Current position: Chief curator, Studio Museum in Harlem, New York. **Former positions** include curator, Whitney Museum of American Art, New York; special projects curator, Peter Norton Family Foundation. **Selected exhibitions**: *Freestyle* (2001, Studio Museum); *Glenn Ligon: Stranger* (2001, Studio Museum); *Isaac Julien: Vagabondia* (2000, Studio Museum); *Bob Thompson* (1998, Whitney); *Whitney Biennial* (1993, Whitney). **Selected publications**: *Black Male: Representations of Masculinity in Contemporary Art* (New York, 1994); *Glenn Ligon: Unbecoming* (Philadelphia, 1998); *Bob Thompson* (New York, 1998)

Hou Hanru

Thoughts on Curating

(from a Conversation with Joan Kee)

Huang Yong Ping, *Bank of Sand,*
Sand of Bank, installation in
Shanghai *Biennial*, 2000

J.K.: *How has being an independent curator affected your outlook?*

H.H.: When I first came to live in Europe, the first question was how to survive without giving up what I believe in. Working with art is not just about considering things in a theoretical way or formulating definitions, but more about putting yourself and art in action, to open up new spaces and possibilities. I think curating is about opening new spaces. Contemporary art is at first a continuous process of creation. An exhibition is an articulated presentation of such an ongoing process and should not be a display of frozen and finished works. It should emphasize the living and performative aspects. To work in a museum is to work in an established framework; you have security, but you also have a limited space to challenge and confront. For me, the point of art is to push the borders, to rethink, to re-imagine the possibilities of going beyond the boundary. I have been lucky to work as a free-lance curator because I've been put in constant crises and dangers. It forces you to be creative and innovative, as much as possible. Of course, it's not really possible to be truly independent, but it's a great challenge—you have to translate the freedom that the artist is trying to express.

I think the main problem for me is that our lives are completely institutionalized. How do we go beyond these constraints, create a space for freedom? It's very difficult. The logic of capitalism, the logic of corporations and their rules are so strong and dominant that we can't really see any way out.

J.K.: Cities on the Move *was an exhibition that changed from venue to venue.*
H.H.: Absolutely. It doesn't make sense to show the exact same work in radically different contexts, because context is a crucial element. Exhibitions should have a site-specific meaning. Just as every so-called "global" product goes through many different transformations, so does art. There's a lot of adaptation. Most of my projects have been conceived of and realized in response to the contexts where the shows take place. The participation of the public in each place is also very important. I remember a Situationist idea that the best city should be the one in which every inhabitant can decide when and how to switch on and off the streetlights. This is a very beautiful vision, even for an exhibition.

J.K.: *Do you find the label "contemporary Asian art" to be problematic?*
H.H.: Yes and no. On the one hand, the label is a practical signifier, but then again, what does it signify? I think we have to be extremely careful; when I curate an exhibition of Chinese or other Asian artists, I try to include artists that are not ethnically Asian, to prove that Asia is not a racial space or a national place. It's a transitional space, a locality which is being continuously re-invested, re-informed, and re-invented by different cultures and the exchanges and negotiations among them.

One of my most recent projects, *My Home Is Yours, Your Home Is Mine* at the Rodin Gallery in Seoul, Korea was organized in collaboration with French curator Jérôme Sans. It is a traveling project, moving from Seoul to Tokyo and then to other places. In each site, we have a collaborating curator from a local institution. In terms of selecting art and defining thematic issues, it's a complicated project involving not

just one or two minds; and active involvement by the artists is also a significant factor. The time when one curator could dominate a project is past; it's now a time of collaboration, exchange, and sharing.

Along with the acceleration of global communication, everything is becoming a surface: things are flattening. Somehow you have to deal with this two-dimensionality, with the ability to transform yourself. I hope the projects I am doing will be able to deal with this in a four-dimensional way.

J.K.: *That might be especially true with regard to* Cities on the Move. *As the works moved, they shifted and evolved, and that utilized the fourth dimension of time.*

H.H: Yes, and the thing we have been learning is that in many cases, the moment you announce the opening of the show, you announce its death, because everything is set. Movement dies; the works no longer change. Doing *Cities on the Move* was an almost unbearable thing for the institution, the audience, and even the artists because the works had to change. This is a challenging concept to those who think that art is a commodity for the market. The market regards art as a thing that does not change. It's time for us to articulate the importance of immateriality, fluidity, performativeness, and change as central to our activities.

Hou Hanru, born 1963, Guangzhou, China
Current position: Independent curator and critic, Paris, France.
Selected exhibitions: *Paris pour Escale* (2000–2001, Paris); *My Home Is Yours, Your Home Is Mine*, (co-curator, 2000–2001, Samsung Museum, Seoul, traveling exhibition); Huang Yong Ping installation for Shanghai *Biennial* (2000–2001); French Pavilion, Venice *Biennale* (co-curator, 1999); *Cities on the Move* (co-curator, 1997–2000; Secession, Vienna, traveling exhibition). **Selected publications**: *Strategies and Games—Chinese Contemporary Art* (forthcoming, 2001–02); *Kunst-Welten im Dialog* (Cologne, 1999); *Cream: Art in Contemporary Culture* (London, 1998)

Yuko Hasegawa

Art in (a New) Context

Works by Yayoi Kusama and Eva
Hesse in *De-Genderism: détruire
dit-elle/il,* 1997

1. Make your own definition of art. Define art beyond your modern
ego—view yourself as a social creature with a highly developed brain,
so that you will be capable of speaking about art to people in differ-
ent cultural contexts and social structures, in your own language.

2. The following is my definition of art: the essence of art, especially
the essence of visual art, is found in its form. Let me use the
metaphor of a river and its water. Water is the material used, and
river flow is the form of the art. In the cerebrum, the material is the
neuron and the form is consciousness. Form created by an artist
reflects the artist's consciousness. When the audience's consciousness
oscillates with this form, inspiration occurs. Oscillation can take place
with strong impact in the deep consciousness, or gently in the shallow
water. The former is often what we call extraordinary art, and the latter
can be a long-selling design product. There is no clear line dividing
the two. It is up to the curator's intellectual and intuitive work to
select form and create the site of oscillation. Do not limit yourself to
restrictive categories such as fine art, artifacts, or applied art.

3. The work of the curator is to be an intermediary between artwork and audience, to inspire people to the potential within artwork, and to spark the interaction between the two. However, there are certain limits. Mounting an exhibition usually involves the transfer of artworks. When works are moved from the place of their origin to another site, comprehension of their significance can become limited. Naturally, new interpretation and misunderstanding of the work often occurs in a different cultural context and site.

4. Work with unknown art that will teach you something new rather than art with which you are familiar and comfortable.

5. Language differences are an unavoidable problem. If you are a curator from a peripheral region—such as Asia or Eastern Europe or Scandinavia—you must be aware that the mainstream discourse of art is expressed in English, German, or one of the major Romance languages, and that there are inevitable limitations in communication due to the extreme differences between the syntax of these languages and that of your own language. (Being from an English- or Spanish-speaking country that is far from the art centers of Europe or the U.S. does not diminish the cultural differences, even if it provides a partial advantage in communicating.) However, you can usually count on the fact that what is expressed directly by your exhibition (i.e., the art itself) will fill the gap in interpretation and discourse. Also, be confident that there can be unique kinds of texts, museum systems, and exhibitions that are only possible in peripheral places.

6. In the process of preparing an exhibition of an artist's work, let your curatorial desire collide with the artist's desire. In the end, let the artist have his or her way. It is something like creating a spiritual magnetic field, rather than collaboration. Of course, the ways of communication should be different with each artist. The latter, when contemplating the exhibition space, should be left alone, and should not be approached until he or she is ready.

7. If you are a female curator from a peripheral country, you will be more likely to face discrimination, unfair underestimation, and prejudice, which are rarely experienced by male curators, especially those from mainstream countries. Be aware that your disadvantages make you a sensitive and perceptive observer, and give you a critical consciousness. At the same time, be careful not to fall into expected stereotypes.

8. The role of the curator is not only to be a thinker, but also to be a communicator, to explain your thoughts visually through exhibitions and projects. The balance of intuition, intelligence, and sensitivity is very important. It is as if you are the conductor of an orchestra; curating an exhibition involves the art of creating harmony and atmosphere. The very existence of a curator activates the exhibition space and works to pull everything together.

Yuko Hasegawa, born Hyogo Prefecture, Japan
Current position: Chief curator, Contemporary Art Museum, Kanazawa, Ishikawa Prefecture. **Former positions** include art director, seventh Istanbul *Biennial* (2001); curator, Setagaya Art Museum, Tokyo; visiting curator, Whitney Museum of American Art, New York. **Selected exhibitions**: *De-Genderism: détruire dit-elle/il* (1997, Setagaya Art Museum, Tokyo); *Liquid Crystal Futures* (co-curator, 1994–96, Fruitmarket Gallery, Edinburgh, traveling exhibition). **Selected publications**: "Cai Guo-Qiang," in *Global Art Rheinland* (Bonn, 2000); *Making a Museum for the Twenty-first Century: Visualize the Invisible Value* (Kanazawa, Japan, 2000); *The Discourse of Representation, Imagination: The Creators and the Created* (Tokyo, 2000); "Pachinko, Mandala and Merry Amnesia: Modern Japanese Art and Its Background," in *Japan Today* (Vienna, 1997)

Maria Hlavajova

Vade Mecum? I Wonder

Ene Liis-Semper, *FF/Rew*, 1998,
in *Ene-Liis Semper: Oasis*,
BeganeGrond, 2001

Each time I type the word "curating " (even now), Microsoft Word
underlines it in red. With curiosity, I always rush to scan the list of
spelling substitutes (*crating, curetting, curtain, coating, crusting*) and,
relieved and more than happy, I click on *Ignore All*. Somehow I enjoy
this game, as in its very core it articulates what curating means to me:
a continual process of "becoming oneself," a practice somehow related
to, on the one hand, culture production and, on the other hand, the
audience; a practice that in its constant changing among various
possibilities ultimately withdraws from any categorizing and escapes
clear definition. It is an identity in perpetual transition, absorbing
erratic social, geopolitical, ethnic, economic, and other realities on a
plateau of the intensely lived ordinary, and therefore resistant to the
framing of a dictionary or a guidebook, a ready-to-use manual.

Yet I find myself writing for this *Vade Mecum*. And I must confess,
I feel a little insecure. Do I really have to reveal my uncertainties, my
limitations, to comprehend the entirety of the contemporary? Should
I confess that it is never a goal but rather a journey shaping my work,
a road that tends to break the proposed limits but misses the planned
destination? That my practice is an archive of (optimistically produc-
tive) failures? That, rather than my making a unilateral choice, I opt
for partnerships, both intellectually and in terms of building a platform

for producing new work? And also that I need a small but flexible space, a working environment subtle in scale but dense in potentials and possibilities, energy and experimenting? As for people, I need a good team working with me rather than around me.

My collaborators in these partnerships (as you might have noticed, the word "artist" seems to have momentarily lost its previously sharp contours and clarity to me) are practitioners whose work often transgresses the borders of one field and who often come from various disciplines, often beyond the purely visual. I have tried not just to "look at" and "read about" art but to "experience" it—to both think and feel through discursive mode. A dialogue avoiding ideology of consensus, a negotiation of meanings, an intense cooperation, a co-production of temporary situations in sync with the real—well, the way I understand, negotiate and live the "real" through—form for me the best way of thinking about the "now." A "becoming" rich in its meandering. Constant flux.

If Microsoft Word ever recognized the word "curating," it would make me a little bit sad. The world of trying out, testing new attitudes, rethinking, and pushing boundaries would freeze in that particular moment. No longer "becoming." No more room left. However, I promise to sit down then and list all the "words of wisdom" on what has made my life so enjoyable.

Maria Hlavajova, born 1971, Liptovsky Mikulas, Czechoslovakia **Current position**: Artistic director, BeganeGrond, Center for Contemporary Art, Utrecht, The Netherlands. **Former positions** include faculty member, Center for Curatorial Studies, Bard College, Annandale-on-Hudson, New York; director, Soros Center for Contemporary Art, Bratislava, Slovakia. **Selected exhibitions**: *Common Ground* (2001, BeganeGrond); *Borderline Syndrome—Energies of Defense, Manifesta 3* (co-curator, 2000, Ljubljana, Slovenia); *There Is Nothing Like a Bad Coincidence*: *Art from Central Europe* (1998, Bratislava), *Ephemeral Exhibitions* (1997, Bratislava); *Interior vs. Exterior, or On the Border of (Possible) Worlds: Contemporary Art from the Slovak and Czech Republics* (1996, Bratislava)

Robert Hobbs

If Works of Art Are Considered Scores, Their Performances Are Exhibitions

Installation view of *Lee Krasner,*
Los Angeles County Museum
of Art, California, 1999–2000

Contrary to received wisdom, works of art do not speak univocally; they are multivalent signs. Their meanings are many, and their contents depend on the orientation of viewers and the special circumstances in which they are seen. Belief in art's purity is akin to Arthurian knights' searching for the Holy Grail and Romantics' embracing an unadulterated nature. While such quests might seem harmless—after all, what is the danger in considering art a surrogate religion?—such soporific thinking is exceedingly perilous for twenty-first-century curators who must come to grips with the fact that art changes subtly but definitely each time it is presented. As curators, we are inscribed in the process of looking and understanding art, and are not extrinsic to it and uninvolved in its results. Just as physicists' questions regarding the state of light can produce differing responses, depending on whether it is perceived as energy or matter, so the intellectual and physical arrangements of individual objects can become the bases of new and varying interpretations

Since Heinrich Wölfflin established in the early twentieth century his Renaissance/Baroque polarities, the pedagogy of art history has been premised on pairs of slides because the ensuing comparisons

permit new constellations of thought and innovative ways of seeing. Although this approach might appear to have been ratified throughout the discipline solely because it made art historians crucial to looking and interpretation, such a conclusion does not account for the fact that looking always involves comparisons and contrasts. Objects are always dependent on the explicit circumstances in which they are shown. Context-dependent, such works of art as State and family portraits, altarpieces, and Psalters elicit new responses when they are removed from their originally intended destinations and are relocated in museums. Even museum-oriented objects, which have become commonplace since the time of Manet, take on the coloring of their specific circumstances. When I exhibited Robert Smithson's early quasi-Minimalist sculptures in La Jolla in the early 1980s in a museum gallery where the white caps of the Pacific could be seen, they looked merely elegant and decorative. But when they were later shown at the Whitney, their industrially fabricated forms covered with white refrigerator paint appeared rational, dry, and highly articulated. In addition to recognizing the profound roles they play in consigning objects to intellectual and physical spaces, curators need to be aware of a profound shift that has occurred in art since Minimalism: art's move from ontology to epistemology.

Instead of becoming involved with art's alleged being—which Clement Greenberg and Michael Fried in the 1960s temptingly called "presence" and "presentness"—prescient artists have used objects to catalyze viewers' inquiries regarding art's status, truisms, and outreach. Anticipating the now prevalent critique of art's purported quasi-religious status, Conceptual artists initiated the trend of rejecting the idol of art for the envelope of residual reactions to it, placing theory and reception on a par with their objects.

This shift from art as autonomous object to art as a mode of ongoing communication and inquiry has already had an enormously liberating effect for curators that can be mined even more if they are willing to take responsibility for the collaborative and interpretative roles they assume when organizing exhibitions. In the future, curators will feel compelled to place more emphasis on the metahistory of

curating. Although they need not aspire to the status of auteur, they must inaugurate the long process of taking responsibility for their actions by assigning their names to all their installations, even those focusing on permanent collections, as Tate Modern curators have begun to do. Only then can curators as well as the general public begin to appreciate how placement can enunciate a work of art with as much, if not more meaning, than a pianist's specially colored musical phrases.

Robert Hobbs, born 1946, Brookings, South Dakota, U.S.
Current position: Rhoda Thalhimer Endowed Chair of Art History, Virginia Commonwealth University, Richmond, Virginia. **Former positions** include director, University of Iowa Museum of Art, Iowa City; curator, Herbert F. Johnson Museum of Art, Cornell University, Ithaca, New York. **Selected exhibitions**: *Milton Avery: The Late Paintings* (2001, American Federation of Arts, New York); *Lee Krasner* (1998–2001, ICI traveling exhibition); *Souls Grown Deep: African-American Vernacular Art of the South* (1996, Michael C. Carlos Museum of Art, Emory University, for 1996 Cultural Olympiad, Atlanta); *Robert Smithson: Sculpture* (1982, Herbert F. Johnson Museum); *Abstract Expressionism: The Formative Years* (1978, Whitney Museum of American Art, New York)

Mary Jane Jacob

A Recipe for Exhibitions

Kate Ericson & Mel Ziegler,
Camouflaged History, in *Places with
a Past: New Site-Specific Art in
Charleston*, 1991

Ingredients:
Art
Artists
Audiences
Spaces (variable)
Institutions (optional; at some altitudes, not recommended)

Start with art and let it lead you to its makers: propose questions
that concern you and that you care about, unanswerable questions
that are worth investigating to find ways of thinking about them.

Be a partner to explore these questions—widely and fully and
openly—with artists who are also thinking about them and for
whom thinking about these questions can move their work.

Imagine a realm of opportunities for artists to make art and for
their art to communicate and have an impact on others (even if
the means to bring them about don't yet exist); think about what is
needed and what could happen, then find ways to make it happen.

Venture ideas about what art can look like, what it can mean,
what it can do; artists will use this or discard it, but these ideas

will enter into the dialogue and fuel the process as you contribute to their product: art.

Listen to artists as they venture ideas that reflect back on your exhibition-making practice; you can use or discard them, but the interaction with artists will fuel your process and change your product: the exhibition.

Listen to audiences while you are in the process of making the exhibition, and then remember to report back to them: to make the exhibition a mode of communication.

Locate your reason for doing an exhibition, and what it contains and what it looks like will follow. Your aims can be multiple, but locate the one that connects you to art beyond the immediate exhibition and that can thread through a lifetime of work.

Trust that art will make things happen about which you will never know, be able to track, evaluate, quantify, or write, but that may return to you in another form, in your own work, in the work of others, in art, and in life.

Mary Jane Jacob, born 1952, New York, New York, U.S. **Current positions**: Independent curator, Chicago; faculty member, Center for Curatorial Studies, Bard College, Annandale-on-Hudson, New York; faculty member and graduate advisor, School of the Art Institute of Chicago. **Former positions** include chief curator, Museum of Contemporary Art, Los Angeles; chief curator, Museum of Contemporary Art, Chicago. **Selected exhibitions**: *Awake: Art, Buddhism, and the Dimensions of Consciousness* (2001–04, U.S. consortium of institutions); *Listening Across Cultures and Communities* (2001–02, Spoleto Festival, Charleston, South Carolina); *Culture in Action: New Public Art in Chicago Sculpture* (1992–94, Chicago); *Places with a Past: New Site-Specific Art in Charleston* (1991, Spoleto Festival). **Selected publications**: *Conversations at The Castle: Changing Audiences and Contemporary Art* (Cambridge and London, 1998); "Removing the Frame," in *Conversations Before the End of Time* (London, 1995); "An Unfashionable Audience," in *Mapping the Terrain: New-genre Public Art* (Seattle, 1995)

In photo above: Mary Jane Jacob with artist Christian Boltanski

Maaretta Jaukkuri

Curating

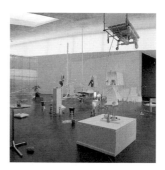

Work by Honoré d'O in *Delicate Balance*, 1999–2000

I have a very ambivalent attitude toward the curator as auteur or independent voice. When conceptualizing exhibition themes or writing catalogue texts, the curator does, of course, create a voice—perhaps even a guiding voice—for the viewer to follow when visiting the exhibition. But I do not think a curator should become involved in the production of a work in any other role than that of a sounding-board—when and if the artist so desires. A curator's excessive engagement in this process can result in what might be termed "curator's art," which often seems aimed at culture festivals and biennials. From the moment I decide to invite an artist to participate in an exhibition, even if I think I know which work(s) I am interested in, I express my trust by letting the artist make all the decisions concerning his or her work, including which one(s) to feature.

The recent exhibition *Delicate Balance: Six Routes to the Himalayas* is a case in point. I invited an international group of artists to take a trip together to the Himalayan mountains, requiring only that each of them make an artwork afterward that would convey his or her responses to the trip. I collaborated on this project with Finnish artist Jussi Heikkilä, who had initially come up with the idea of a trip where the artists would collect rubbish that has accumulated on the Himalayan slopes. I chose to take his idea of an artist's trip to this

region and change its focus to the different ways that six artists from very different backgrounds would experience such a journey. Besides Jussi Heikkilä, the artists were Xu Bing, Honoré d'O, Simryn Gill, Jussi Heikkilä, Hans Hamid Rasmussen, and Liisa Roberts. Before they left, I spoke with them about a possible approach to the project, emphasizing how much our perception is informed by our cultural background so that even when our experiences are the same, we translate them into pictures or texts in different ways. None of the artists was very enthusiastic about this approach, so we decided to leave things open and let each choose what he or she wished to convey to us afterward. The artists went on their trekking expedition in October 1999. I was very worried about them.

Contrary to our plans, the six artists actually spent very little time together: One got sick on the way to Nepal, another upon arrival in Kathmandu. A second group started out late. Physically, the trekking route turned out to be too hard for the two women, and they left the group a week early. The internal dynamics of the whole group were never quite in place; the sight of widespread poverty put an additional strain on them.

Just before starting the trek, the artists had a long discussion about why they were there and what the curatorial goal of the trip was supposed to be. Some felt frustrated that the mission was not more clearly defined, and tried to turn Heikkilä—the Finnish artist and the "father" of the idea—into a kind of temporary curator, a role he refused to play.

For me, the discussion and even the confusion of the whole situation were very enlightening. I had declined to give the project a theme, not being able to anticipate the artists' experience. Yet the freedom that they had been given seemed somehow disturbing, perhaps more so in a group situation. Afterward, however, all the artists agreed that this freedom had been the only possible way to approach the project. The exhibition at Kiasma in the summer of 2000 provided a fascinating document of the different ways the six artists had experienced their journey, ranging from a sculpture about balancing to a cartoon strip published in a Kathmandu newspaper.

The Himalayan project reminded me once again that the curator's role is to create the premises and possibilities for artists to work in as freely as possible. In this case, the premises were rather extreme, but the artists had been well aware of them. Gilles Deleuze once remarked that we should not get involved in things that do not in some way change us. I think—and the artists agree with me—that we all changed a little as a consequence of the project. However, the most important thing was that the project caught the imagination of at least a part of our public and thus worked as an exhibition.

 Maaretta Jaukkuri, born Rovaniemi, Finland
Current position: Chief curator, Kiasma, Museum of Contemporary Art, Helsinki, Finland. **Former positions** include head of exhibitions, Nordic Arts Center, Helsinki; exhibitions secretary, Artists' Association of Finland. **Selected exhibitions**: ARS 01 (co-curator, 2001, Helsinki); *Delicate Balance: Six Routes to the Himalayas* (1999–2000, Kiasma, Helsinki); European section of *Roteiros, roteiros, roteiros . . .,* in São Paulo *Bienal* (co-curator, 1998); *Face to Face* (1991, Kiel, Germany, traveling exhibition); *Per Inge Björlo, Rolf Hanson, Jukka Mäkelä,* in Venice *Biennale* (1988). **Selected publications**: "Liisa Robert's Trap Door," in *Blikk på Kunst* (Oslo, 2001); *Artscape Nordland* (2000); *This Side of the Ocean* (Helsinki, 1998); "The Annual Book of the Ateneum Art Museum," in *Interpreting Contemporary Art* (Helsinki, 1998)

In photo above: Maaretta Jaukkuri with sculpture by Riley Robinson

Milena Kalinovska

A Reflection

Marjetica Potrč, *Built Disaster*, at
Project Space, Washington, D.C.,
1998

Ryszard Stanislawski, the distinguished director of Museum Sztuki in
Lodz, Poland, came to visit the Riverside Studios in London in 1984,
when I was director there. The Riverside Studios was an experimental
arts center, known especially for its international theater programming
and for staging productions of plays by Samuel Beckett, Tadeusz Kantor,
and Dario Fo, among others. It also included a gallery space resembling
an industrial warehouse, where Stanislawski was considering exhibit-
ing the most important collection of Polish Constructivist art from
1923 to 1936. At that point, other professionals felt that only a major
museum in London would be appropriate for these remarkable works,
previously exhibited at the Rijksmuseum Kröller-Müller in Otterlo in
the Netherlands and at the Centre Georges Pompidou in Paris.

When Stanislawski saw the early sculptures of Richard Deacon in
Riverside's gallery, his face broke into a broad smile. I knew then that
Riverside would get to present the show. We settled on the exhibition
dates he proposed, and I promised to offer training opportunities at
the gallery for two of his young, talented staff members. Later that
day, on the way to a lunch organized for him by one of senior curators
at the Tate Gallery, he asked me, "Am I invited out of respect or pity?"

Meeting and collaborating with Stanislawski on that exhibition
clarified for me personally several characteristics that made him

exceptional among museum curators and directors not only in Eastern Europe but in fact anywhere. At a time when it was difficult in Poland to show groundbreaking historical exhibitions or adventurous contemporary artists from Poland, let alone from other Eastern European countries (these especially were kept apart in case they would find affinity with each other) or the West, he did it all. How?

Stanislawski was close to many artists, and he eagerly communicated with them and spread the word about them. Unbeholden to institutions and uncorrupted by the prospect of power and status, he has managed to retain professional curiosity (about new possibilities for artists), responsibility (for the mission of his profession), and generosity (toward people). His actions and behavior have made it clear to me that it is a privilege to become familiar with a culture or an issue that appears "marginal" to most people. It provides a curator with an opportunity to experiment with novel interpretations of art history and to work toward transforming models of exhibiting. For me, the curatorial challenge is to keep the door open for diverse interaction among various artworks, and in this way to advance both the visual and conceptual experience.

Milena Kalinovska, born Prague, Czechoslovakia

Current position: Independent curator, Washington D.C., and Prague, Czech Republic. **Former positions** include director, Institute of Contemporary Art (ICA), Boston; adjunct curator, New Museum of Contemporary Art, New York; exhibitions director, Riverside Studios, London. **Selected exhibitions**: *Beyond Preconceptions: The Sixties Experiment* (2000–2002, ICI traveling exhibition); *Art into Life: Russian Constructivism 1914–1932* (co-curator, 1990, Seattle); *Magdalena Jetelova: Sculpture* (1985, Riverside Studios). **Selected publications**: "Exhibition as Dialogue: The 'Other' Europe," in *Carnegie International* (Pittsburgh, Pennsylvania, 1988); "New Forums for Expanding Internationalism," *Arts International* 1988

In photo above: Milena Kalinovska with sculpture by Hélio Oiticica

Vasif Kortun

Whatever I Say Fades Faster than the Pages of the Book You Are Holding

Installation view of *Karma Sergi*,
Galatea Gallery, Istanbul, 1999

My six-year-old daughter used to look at registrars' Polaroids of works
in crates, come with me to opening parties, and leave her footprints
on white walls. And, as smart as she is, instead of the word curator,
she says, "Dad is in the arts." I hope this fundamental lack of anxiety
in her understanding between an "artist" and a mediator (of a work
or a situation) will never disappear.

I just got on the Net and brought up the Rooseum site in Malmö,
Sweden (www.rooseum.se/). The site is under construction, but there
is a precise explanation about the ways in which the Rooseum will be
directed when it reopens. After reading it, I promptly erased all I had
written the day before. The Rooseum text goes like this: "Now, the term
'art' might be starting to describe that space in society for experimen-
tation, questioning, and discovery that religion, science, and philosophy
have occupied sporadically in former times. It has become an active
space rather than one of passive observation. Therefore, the institutions
to foster it have to be part community center, part laboratory, and
part academy, with less need for the established showroom function.
They must also be political in a direct way, thinking through the
consequences of our extreme free-market policies."

Substitute imagination with advice. If you can't dream—you know
if and when you can't—try securing a museum position. You will not

have an endless supply of great ideas in life, so don't get arrogant. Know the art of the last thirty-five to forty years; never turn your practice into a daily routine; never accept a project if your heart is not in it.

Making exhibitions is neither a duty nor a job. An "exhibition" is a temporary, relatively sovereign space for—hopefully—experiment and reflection, which puts art together with a public. It can bring forth new conditions toward more just, more tolerant, more ethical ways of being part of the world.

I just got back on the Net and read an article in the Sunday *New York Times* (February 18, 2001) about the massive proliferation of contemporary-art tourism. Art as lifestyle has been in the making for a long time. I am reluctant to spoil the party. How can I? Numbers mean everything! There has been a transformation of the financially robust segment of the contemporary-art sector, with artists, galleries, and museum institutions becoming compliant tools of the new (entertainment) economy. For them, it is not a survival move. For no apparent reason, they just want a return to the late eighteenth century (when the Salons and Royal Academy began) and to be in the epicenter of the charade. For others, this "new" lifestyle means obliteration, domestication, ghettoization, and micro-streamlining.

 Vasif Kortun, born 1958, Istanbul, Turkey
Current position: Founding director, Proje4L, New Istanbul Museum of Contemporary Art. **Former positions** include director, Center for Curatorial Studies Museum, Bard College, Annandale-on-Hudson, New York; director and chief curator, Istanbul *Biennial* (1992). **Selected exhibitions:** *Unlimited #4* (2001, De Appel Foundation, Amsterdam); *Confessions of a Voyeur* (2000, Dulcinea Art Gallery, Istanbul); *Young Art-3 Ankara* (2000, Cankaya Belediyesi Cagdas Sanatlar Merkezi, Ankara, Turkey); *One Special Day* (1999, Istanbul Contemporary Art Project); *Roteiros, roteiros, roteiros...*, in São Paulo *Bienal* (co-curator, 1998). **Selected publications:** *Fresh Cream: 10 Curators: 100 Artists* (London, 2000); *Bulent Sangar: Living and Working in Vienna* (Vienna, 2000)

Charlotta Kotik

A Few Droplets of Wisdom

Installation view of *Louise Bourgeois: The Locus of Memory*, 1994

I doubt I possess many words of wisdom, but I will try to muse a little about being a curator of contemporary art. Whether I am organizing exhibitions at the Brooklyn Museum of Art or independently, integrity of approach and devotion to art and artists are paramount in my work. Sounds old-fashioned? Yes it is, but I still believe it to be true. If you are in this profession, you must have—in addition to those two ironclad principles—a clear vision of what you want to achieve and the honest means that will take you there. Never be afraid to experiment if need be, and don't give up; believe in your idea—your enthusiasm will become contagious and will help you along the way.

Now, more than ever before, art is experienced by large audiences of very diverse backgrounds. It is exhilarating to give a wide array of people the opportunity to contemplate, enjoy, and learn from your projects. When I saw people lined up to visit three of the exhibitions I organized—*The Play of the Unmentionable, Louise Bourgeois: The Locus of Memory,* and *Current/Undercurrent: Working in Brooklyn*—the pleasure I experienced as a curator was magnified by the interest and enthusiasm shown by others.

Why do I mention these projects when there are others I take pride in? It is because these were highly complex to organize, each requiring different sets of selection criteria and working methods. *The Play of the Unmentionable* brought together previously censored art from all periods of art history. *Current/Undercurrent* featured present-day works by more than two hundred young artists from the Williamsburg section of Brooklyn. The Louise Bourgeois exhibition entailed choosing several dozen pieces from the extensive and complicated oeuvre of one of the seminal sculptors of the twentieth century. Organizing these three exhibitions required a broad scope of knowledge, not only art-historical but also sociopolitical. Nevertheless, however different the exhibitions were, I found that the process of determining the final checklist for each of them was similar in certain fundamental ways. In all cases, the qualities of each work being considered for inclusion were rigorously analyzed and questioned, and when the reasons for its selection were eminently clear—namely, by its illuminating the theme of the show—the choice became final.

There always seem to be more works that could be appropriate for a given project, so trimming down the selections is essential. Too many works can dilute or cloud the message rather than strengthen it. Thoughtful choices suggest new formal and conceptual relationships that bring out the unnoticed qualities of the works. The strength of the individual works is supported by careful installation, devised by the museum designer but discussed in detail with the artist(s). This exchange of ideas can reveal different expectations on the part of the artists and institution alike, and it is essential, as it gives additional insights into the "character" and "personality" of the exhibited pieces. The more time spent on studying the works and discussing them with colleagues, artists, and, if possible, the general public, the more sound the presentation becomes. This might become more and more difficult in a world oriented toward speedy production, but to take time to think is still the best way to achieve a successful presentation.

With geographical distances seemingly shrinking through technology, the responsibility of the curator grows dramatically, and so does the need for understanding a multitude of issues other than those directly connected with one's immediate environment. The social responsibility of a curator is immense—almost as large as the pleasure derived from the privilege of being one.

Charlotta Kotik, born in Prague, Czechoslovakia **Current position**: Chair of Department of Contemporary Art, Brooklyn Museum of Art, Brooklyn, New York. **Former positions** include curator, Department of Prints and Drawings, Brooklyn Museum of Art; curator, Albright-Knox Gallery, Buffalo, New York. **Selected exhibitions**: *Domestic Transformations: Working in Brooklyn* (1998–1999, Brooklyn Museum of Art); *Louise Bourgeois: The Locus of Memory, Works 1982–93* (1994, Brooklyn Museum of Art); *Joseph Kosuth: The Brooklyn Museum Collection: The Play of the Unmentionable* (1990, Brooklyn Museum of Art); *Fernand Léger: Retrospective* (1982, Albright-Knox). **Selected publications**: "The Legacy of Signs: Reflections on Adolph Gottlieb's Pictographs," in *The Pictographs of Adolph Gottlieb* (New York, 1994); Introduction to *Louise Bourgeois: The Locus of Memory, Works 1982–93* (New York, 1994); Introduction to *Joseph Kosuth: The Brooklyn Museum Collection: The Play of the Unmentionable* (New York, 1991)

Maria Lind

Selected Nodes in a Network of Thoughts on Curating

Work by Apolonija Šušteršič in
What If, 2000

Today I was reminded of how often snow can transform one's experience of landscape and of driving. What was totally black suddenly becomes light (literally) and the mystical sounds of the forest are replaced by silence—like having a fur cap drawn over your ears and tied tightly under the chin. The familiar road becomes strange, slippery as glass, and takes on new contours. I make a great effort to avoid the huge snowdrifts and keep on the road. Our main electricity-supplier is taken by surprise and thousands of households are deprived of electricity in the winter cold and darkness. Truck drivers resolutely attach ploughs to their vehicles and clear even the small roads more quickly and thoroughly than I can ever remember.

For me, art continues to be, in competition with other phenomena and means of understanding, the most complex and challenging form for processing the experience of being human, in all its facets. Art is very suitable for testing ideas and thoughts, for questioning and challenging the condition of things; but also for galvanizing words, for moving to act. Art can be a platform for investigations, where the concrete and the abstract, the specific and the general can share the same space at the same time. At worst, art carries an apparatus as large and clumsy as that of a feature film or amusement park; at best, it travels with the light baggage of an ornithologist or a hitchhiker.

How can one combine skepticism with enthusiasm? multiplicity with precision? affirmation with criticism? How does one focus on—and respect—a part and the whole at the same time? These are questions that often crop up in my work as a curator. The lust to discover, to explore and question is paramount, as is seeing each project as a discursive situation. Much of my inspiration and energy comes directly from the artworks and the artists with whom I spend a lot of time; and I am keen to be an enabler, to create the best possible circumstances for the artists (in this context, artists' fees are something of a question of honor). I prefer to take the art itself as the point of departure for my speculations and reasoning instead of starting at the other end, with theory or politics or the academic model where you seek out the smallest common denominator. In other words, the difference between projecting and reducing; digesting and illustrating; osmosis and being a parasite.

For me, the cardinal professional tool is precision. Just as the person who curates an exhibition of classical painting must be attentive to the nuances of the colors of the walls, the lighting, the exact distance between the works, etc., so I must be vigilant about the place, time, duration, and form when working with each individual project, large or small. Each situation must be carefully analyzed and evaluated. Is it an exhibition that is required, or some other form of presentation? This also involves giving a thought or idea, an artwork or an artist, time—time to allow something to mature, and to resist a raw, disposable consumer mentality. Art can exist in many different ways, but the habitual, familiar, and routine is often stronger than new ideas. I want to be sensitive to an artwork's own logic: if it doesn't fit the white cube, or inside an institutional frame generally, it should not be forced into it. When art ventures out to explore the surrounding realities, we who work with it must follow. Both art and its curator would benefit if the curator would follow the lead of the artist a little more often.

To work with different kinds of art projects is to create contexts in relation to and in combination with other existing contexts. I try to be more context-sensitive than site-specific, for the latter often places

too much emphasis on a physical location and a certain intellectual discourse. Instead of anxiously adapting postmodern architecture to its surroundings, the goal is to maintain a sensitivity to situations and to challenge the status quo—being context-sensitive with a twist. For example, organizing a retrospective exhibition of a neglected middle-aged artist; a soft thematic survey of Nordic art in the 1990s with a historical reference to its predecessors in the '60s and '70s and commissioned by a foreign museum; a series of commissions for which the museum employing me functions as a production site, distribution channel, and discussion forum; or it can involve taking the temperature of contemporary art by investigating, in collaboration with the artists, its relationship to architecture and design; or developing other forums for discussions such as think tanks. It can also involve the development of more forms for the mediation of art than the established set; or it can involve establishing a whole new structure in order to link—on a small scale—an art, a culture and a public that seldom encounter each other.

I tend to think of my approach to curating in terms similar to those of many of the artists I am interested in, who work with models and projects, parallel situations and scenarios—not to show what has already been stated, either on the level of content or form, but to test something at least partly new. A lot of the art that interests me possesses a high density—that is, it can seem simple, even banal on first glance, but when one devotes time and attention to it, it grows exponentially: it is slow-burning and incandescent rather than explosive, and often grows on you. For the art I work with, as well as for myself, it is important to relate to everyday experience and to utilize art's inherent ability to communicate. Critique here is like salt. Don't just choose randomly from all the enticing dishes on offer, prepared by adding water and rapidly consumed on the spot. Recipes must be reformulated on every occasion.

The state and municipal art institutions are public spaces whose importance is not diminishing. When t.v. and the Internet, in a not so distant future, no longer attract people the same way as they do today, art institutions will be among of the few public places with

something to offer—entertainment and diversion, of course, but also reflection and questioning. At the same time, many of these institutions have landed at an impasse, and face rampant identity crises. To get out of this situation, I agree with the social theorist/ activist, and Harvard professor of law, Roberto Mangabeira Unger, who proposes practical testing, a kind of institutional experimentation and innovation, where using the imagination is central. This also means holding one's own against corporate involvement and, not least, finding other ways of communicating about art.

Maria Lind, born Stockholm, Sweden 1966
Current positions: Curator, Moderna Museet, Stockholm; co-founder, Salon3, London. **Selected exhibitions**: *Moderna Museet Projekt* (commissions for emerging artists to make new work for various spaces, ongoing since 1998); *Everything Can Be Different* (2001–2003, ICI traveling exhibition); *What If: Art on the Verge of Architecture and Design* (2000, Moderna Museet); *Letter and Event* (1997, Apex Art, New York)

Lucy Lippard

Other Walls

Works by Peter Gourfain and Keith Haring in *Who's Laffin Now*, 1982

As a writer, I equate curating with choosing the illustrations for a book. This won't please artists, but most exhibitions do in fact illustrate some curator's ideas. Books and shows both involve collaborations with artists, directly or indirectly, giving the writer/ curator a chance to say something visually.

What I like best about curating is designing and hanging the show, preferably in unexpected places—streets, stores, windows, an old jail, a union hall, a bookstore, or a community center—rather than in classier but sterile spaces. Though I have to admit art looks better on well-lit white walls with lots of space around it, unconventional and more accessible exhibition spaces make the art live up to its promises. I like bright painted walls, odd sequential groupings, asymmetry, and inclusions of non-art. (The cartoon dialogue balloon painted on the wall was once one of my trademarks.) I like to work with art that is easily traveled, not too precious, that lends itself to "suitcase" shows.

My major influences in this direction are Conceptual art in the 1960s, when I started doing this kind of thing (and, for my pains, was accused of trying to be an artist), and the young "new wave" artists of

the late 1970s to early 1980s—CoLab, Fashion Moda, and especially Group Material. Fred Wilson's *Mining the Museum* (1992) has also opened up another mode of intervention to artists and curators.

Very few of my favorite exhibitions have had catalogues or were even reviewed, so I have to think of curating as a temporary provocation rather than as a message to posterity. The responsibility of the curator (like that of the artist) is to provoke thought and sometimes action, to educate, surprise, and delight. I'm accountable to anyone who takes the trouble to look at a show I've curated. Today, as ever, I'd like to see exhibitions that challenge visual convention, break out of commercial and institutional gridlock, are not dependent on fashion or trends or tons of money to be effective, and take on issues unlikely to be considered within art's purview.

The following are among my favorites of the fifty-odd shows I've organized as a free-lance curator, because they meet the criteria listed above. They often took place off the grid, so-to-speak. They are some of my favorites because I had the chance to innovate without any institutional micro-management or political censorship, and I could install them myself most of the time. Some of them were collaborations, which makes curating much more fun.

• *557,087*, at Seattle Art Museum Annex (1969). This huge show took place indoors and outdoors around the city, and I constructed several of the works according to the artists' instructions, since there was no money for artists' travel; it was motley and chaotic and included a lot of really important Conceptual and post-Minimal art that hadn't been fully recognized yet, from Robert Ryman to Adrian Piper. I followed this with three other exhibitions with numerical titles reflecting the population of the originating cities. The catalogues were all packs of index cards that could be "shuffled." The last exhibition in this series was *c. 7,500* in 1973–74, a show of women's Conceptual art which began at Cal Arts and traveled to U.S. museums (including the Wadsworth Atheneum and the Smith College Museum) as well as going to London. All of these shows demonstrated that bulk was not the point of this kind of art; that

artists could send exhibitions around cheaply without too much dependence on institutions; that locations could be multiple for a single show; and that meanings could shift.

• *Death and Taxes* (1981), all over New York in public spaces including store windows, telephone booths, walls, and bathrooms. This exhibition was a group effort by the members of PADD (Political Art Documentation/Distribution), including me. Unlike most public art, this cost almost nothing (which was our budget), and it hit all kinds of different audiences around the city with a "beware of Reaganism" message. (We could use a show like that again this year, as the ghost of those shameful days re-emerges from the bushes.)

• *Who's Laffin Now?* (1981–82, co-curated with Jerry Kearns), at District 1199's New York gallery. This exhibition included comic strips, comic books, and comic-based art. Keith Haring did a frieze around the baseboard of the whole room. It combined "high" and "low" art, making no distinctions between them. I think young (and old!) curators learn most in non-conventional contexts in which they can really be independent and are forced to rethink the contexts in which art and their own ideas are most effective.

 Lucy Lippard, born 1937, New York City, U.S.
Current position: Writer and activist. **Former positions** include co-founder of Printed Matter, the Heresies Collective and Journal, and PADD (Political Art Documentation/ Distribution). **Selected publications**: *A Different War: Vietnam in Art* (New York, 1989); *Overlay: Contemporary Art and the Art of Prehistory* (New York, 1983); *Six Years: The Dematerialization of the Art Object* (Los Angeles and Berkeley, 1973)

Bartomeu Marí

How and Why

Work by Sigalit Landau in
Voorwerk 5, Witte de With Center,
1996

Describing my practice as an exhibition curator for this publication is
a welcome but difficult task. My entry into this line of work—which I
resist considering a profession—came quite by chance. Although I've
been doing it for more than ten years, I still think the most specific
thing about this job is that it's a self-taught activity.

Because I studied philosophy and not the history of art, the search
for historical sequences in art is more of an accident for me than a
principle. Since the years I spent at the Fondation pour l'Architecture
in Brussels, I have focused on artists rather than works. Almost all of
the financing for a large exhibition—and believe me, I'd love to do a
large exhibition—is fundamentally dedicated to covering the costs
of packaging, transporting, and insuring the artworks. Very, very little
of that money is devoted to stimulating the artists, or offering them
the means they would really need to do something exceptional, to
create surprises.

For me, exhibitions are instruments of knowledge and pleasure
that result from long, intense processes of work, discussion, dissen-
sion, and sometimes agreement with artists and cultural producers
from various spheres. What defines a generational change among the

rather small community of people who dedicate themselves to organizing exhibitions is that, for us younger curators, an ethical posture has come to predominate over aesthetic values. Mounting exhibitions is not decorating the kind of spaces that we see ever more frequently. And even though at the end of my stay in Brussels I believed that, as a way of presenting and exploring art, the exhibition had exhausted its capacities as an instrument of discovery, it was not long before I realized that, despite it all, we have not yet invented anything better.

Art is material arranged in a situation that makes it incongruent with itself. Meaning is constructed from this incongruity and contradiction. (That's why for such a long time my catechism was Venturi's book *Complexity and Contradiction in Architecture.*) And at a time when pedagogy, explanation, and clarity appear to be the duties of an exhibition, what interests me is precisely the opposite: opacity, absolute density. What I mean is this: from England and The Netherlands we hear more and more voices—politicians' voices—demanding that art be made comprehensible to the public. And art can never be comprehensible. From art arises an experience that reconciles pleasure and knowledge in an illogical way—not mathematical, but poetical.

At Witte de With, I've tried to take to an extreme the idea of an institution dedicated to experimenting with the notion of art, on the basis of the conventions inherited from the fine arts and beyond them. Since I have learned most of the things I know about art by working with artists, I focus my efforts on making the artists and their work into the real protagonists of Witte de With's program. Luxury? No, necessity! As Europe endowed itself with more and more art institutions from the 1980s onward, as the physical space dedicated to art appeared to increase, the cultural space for its reception has actually diminished. We see more and more exhibitions that have to do with entertainment, with a certain kind of distraction, rather than with the real objectives of art. I don't say this as a complaint, just as a prosaic observation, with the feeling that, like it or not, I'm bucking the opinion of the majority.

What interests me are the exhibitions that divide the world in two, so that in the consciousness of those who really desire to participate in this thing we call art, the truly exceptional experiences stand clear from beliefs, fears, conventions, and fantasies, like day from night.

Bartomeu Marí, born 1966, Eivissa, Spain
Current position: Director, Witte de With, Center for Contemporary Art, Rotterdam, The Netherlands. **Former positions** include curator, IVAM-Centre Julio González, Valencia, Spain; curator of exhibitions, Fondation pour l'Architecture, Brussels. **Selected exhibitions:** *Raoul Hausmann, 1886–1971* (1994, IVAM); *Hermann Pitz* (1994, IVAM); *Lawrence Weiner* (1994, IVAM); *In the Stream* (1994, IVAM); *Landscape Architecture of the 20th Century* (1993, Fondation pour l'Architecture); *Dan Graham* (1991, Fondation pour L'Architecture). **Selected publications:** *Hermann Pitz: Libros y Obras* (Valencia, Spain, 1994); *Show & Tell: Catalogue Raisonné of Films & Videos by Lawrence Weiner* (Brussels, 1992); *Marcel Broodthaers: L'Architecte est Absent: Le Maçon* (Ghent, 1991)

Jean-Hubert Martin

Untitled

Works by Richard Long (above) and by aboriginal artists from Yuendumu, Australia, in *Magiciens de la Terre*, 1989

1. *What is the single most important piece of advice you can offer a beginning curator of contemporary art?*
It is most important to look at a work of art again and again and afterward to build up an interpretation, and not the other way around.

2. *What kind of exhibitions should be done today? (What do we need to see?)*
We really need to see contemporary art from Africa, Asia, South America, and Oceania presented on the same level on which European and North American art is presented.

3. *Which exhibition would you most like to curate, disregarding any practical issues such as finances, lenders, presenters, etc.?*
I would like to curate an exhibition that would challenge the existing categories and hierarchies inherited from the colonial period—art versus craft, high and low, North and South, among others.

4. *For whom do you curate, to whom (or what) are you accountable?*
I curate for the public who usually goes to museums—with the intention of enlarging this public.

5. *Which do you consider your most important exhibitions, and for what reason?*

Magiciens de la terre (1989, Paris) was completely new in presenting unknown non-Western artists together with the stars of the Western art-scene. *Altars of the World* (2001, Düsseldorf) will be another groundbreaking experience, because it will transcend the borders between religion and art, anthropology and art history.

6. *What is the responsibility of a curator?*

A curator's task is to promote a particular vision.

7. *How did you develop your curatorial skills? (What were some of the most important concepts/exhibitions you absorbed? When?)*

The curatorial skills are developed by working together with the artists. Their mode of perception is an aesthetic one and differs from the art historical point of view of the curator, whose approach, hopefully, is broader than just art-historical. It is essential to have not only discussions but also practical and physical experiences with artists to broaden your sensibility.

8. *What do you consider the most important tools of a contemporary arts curator?*

A curator's eyes and brain are the most important inner tools; a hammer, a cellular phone, and a kickboard, the most important external ones.

9. *Which moment do you curate for? (For now or posterity; are you capturing the zeitgeist, or shaping the future?)*

I curate only mindful of the present moment. For a contemporary-art curator, as for an artist, being really in one's time and having a sharp sense of the zeitgeist sometimes means that an exhibition might not be understood right away by the public and, especially, by the critics.

10. *A temporary construct to begin with, how does an exhibition t ravel best?*
The best exhibitions travel in the mind.

11. *What have been the major changes in the role of the curator over the last 25 years?*
Today, curators have a freedom that allows them not to follow the art market. A network of biennials, grants, etc. has been established and it is possible for certain artists with non-commercial works to survive without galleries or collectors. The curator can cooperate directly with these artists.

12. *How important is curatorial mobility?*
A curator has to be mobile in order to find art where it is created and bring it to the people. A glocal point of view means "think global, act local."

Jean-Hubert Martin, born 1944, Strasbourg, France
Current position: General director, Museum Kunst Palast, Düsseldorf, Germany. **Former positions** include director, Musée National D'Art Modern, Centre Georges Pompidou, Paris; director, Musée National des Arts d'Afrique et d'Océanie, Paris. **Selected exhibitions**: *Sharing Exoticisms*, in Lyon *Biennale*, France (2000); *Galerie des Cinq Continents* (1995, Musée National des Arts d'Afrique et d'Océanie); *Magiciens de la Terre* (1989, Centre Pompidou); *Paris–Moscou* (1979–81, Centre Pompidou, traveling exhibition); *Francis Picabia* (1976, Grand Palais, Paris). **Selected publications**: *Le Château d'Oiron et son Cabinet de Curiosités* (Paris, 2000); *Kunst im Verborgenen: Nonkonformisten in Russland, 1957–1995* (Munich, 1995); *Man Ray: Photographe* (Paris, 1981)

Rosa Martínez

Think It Over

Works by Louise Bourgeois,
Carsten Höller, and Laura
Vickerson in Istanbul *Biennial*,
Hagia Eireni Church, 1997

Oscar Wilde said one should never give advice, especially good advice. And yet, here I am, attempting to indicate the best roads for an exhibition organizer to take. In my case, being a curator was not the result of an early vocation but a process of becoming, which I've had to build up step by step; a kind of destination I've had to discover slowly, guided at times by necessity and at others by chance. Today, setting up exhibitions is a privileged way of creating new political and aesthetic territories. There are no reliable maps nor fail-safe recipes for producing a good exhibition, but flexibility is vital for adapting to the most rugged terrain, as is a staunch defense of one's inner convictions and a passion for discovering new routes.

In my view, a curator should be:
• a polymorphous being, but not a perverse one
• an intrepid explorer with radar capable of picking up almost imperceptible signals
• a diplomat with honed negotiation skills
• a guerrilla intent on promoting social change
• an economist capable of clinching the best deal in an exchange
• a therapist who can help change someone's perception of problems
• a "proposer" able to stimulate critical awareness
• a person willing to share both problems and success

• a bamboo rod, both strong and flexible, sensitive to currents without being swept away by them.

These were my feelings and my goals when I organized such exhibitions as the Fifth International Istanbul Biennial, *On Life, Beauty, Translations and Other Difficulties* (1997); *Looking for a Place*, the third *Biennial* at SITE Santa Fe (1999); and the EVA 2000 Biennial in Limerick (Ireland) entitled *Friends and Neighbours*.

In short, to give advice both ambiguous and precise—with the openmindedness born of uncertainty, with the cautiousness of experience, and with the confidence inspired by New Feminism—I take the liberty of offering you the following three quotations. Read them and see if you are persuaded:

• "Choose a lofty role model; not to imitate but to surpass."

—Baltasar Gracian

• "Be careful with what you wish, you might get it."

—Oscar Wilde

• "Sometimes a woman has to do what a man has to think over."

—Anonymous

Rosa Martínez, born Soria, Spain

Current position: Art critic and independent curator, Barcelona, Spain. **Former positions** include artistic director Istanbul *Biennial* (1997); artistic director, third *Biennial* at SITE Santa Fe, New Mexico (1999). **Selected exhibitions**: *Manifesta 1* (1995, Rotterdam, The Netherlands); *Friends & Neighbours* (2000, Limerick, Ireland); *Leaving the Island* (2000, Pusan International Art Festival, Korea); *Living and Working in Vienna* (2000, Kunsthalle, Vienna); *Trans Sexual Express Barcelona 2001* (2001, Centre d'Art Santa Monica, Barcelona). **Selected publications**: "On Love, New Feminism and Power: A conversation between Ghada Amer and Rosa Martínez" (Seville, Spain, 2000); *Peace* (Zurich, 1999); *Cream: Art in Contemporary Culture* (London, 1998)

Justo Pastor Mellado

My Work as a Curator

Work by Cecilia Vicuña in *Historias de Transferencia y Densidad*, 2000

The curatorial profession does not have a fixed job description. Working as a curator in a city such as New York, London, or Tokyo— model global cities with excellent cultural institutions and museums— is very different from working as a curator in a city where museums, at best, have the chance to become venues for curatorial projects created elsewhere, often in those global cities. This is what I call "service curatorship," an organizational extension of the expository vanity of the big institutions that legitimize and safeguard contemporary art.

Curatorial work in South America is an "infrastructure-producing" venture. An ethically conscientious curator questions the systematic sclerosis of art history and points out the weak links in museum practice and policy. However, under the circumstances that prevail in this region, curators perform the role of producing consumables for posterity in an institutional context lacking any type of archives or files and plagued by a progressive weakening of the State entities that, until now, have been in charge of museum activity.

The curatorial departments in which I have worked have endeavored to prevent the use of false analogies in a historical misreading of our own avant-garde movements of the past as merely being the South American version of this or that European or North American movement. This calls for the formulation of hypotheses based on a

representative selection of works, rather than imposing existing theories on a body of work and thereby seeking to illustrate the theories with the work.

One exhibition I curated, *Historias de Transferencia y Densidad* (which was about the troubled past of the Chilean art scene from 1973 to 2000), took shape through a theory constructed around the conceptual and historical ideas with which the works were invested. The exhibition was organized around two poles: the home and the body—that is, the "yearning for a home" evident in much Chilean art and the representation of corporeality—within the context of a visual nexus that we called "the arts of excavation." The issues of home and body have defined my work as a curator for the past ten years. On the one hand, the house, or museum institution, which is lacking; on the other, the body, made visible only by its trappings, fragments, and objects.

Justo Pastor Mellado, born 1949, Chile

Current positions: Art critic, independent curator, member of the Advisory Council of the National Museum of Fine Arts, director, Art School of the Pontificia, Universidad Católica de Chile. **Selected exhibitions:** *Historias de Transferencia y Densidad* (2000, Museo Nacional de Bellas Artes, Santiago, Chile); second Lima *Bienal*, Peru (1998); Sao Paulo *Bienal* (co-curator, 1998). **Selected publications**: *Dos textos tácticos* (1998); *La novela chilena del grabado* (1995); numerous essays on contemporary Chilean artists, including José Balmes, Gracias Barrios, Gonzalo Díaz, Eugenio Dittborn, and Arturo Duclos

Andrea Miller-Keller

Sentences on Being a Curator
of Contemporary Art

Work by Daniel Buren in
MATRIX, 1977

1. Listen carefully to those you respect, especially artists.

2. When day is done, trust your own instincts.

3. Be efficient. Do not linger in front of work you know is weak.

4. Respect the general public.

5. Be the artist's advocate.

6. Keep a low profile. It is the art and the ideas that count.

7. Do not worry about looking smart. Much that is important is not self-evident. Ask questions.

8. Reflect carefully upon works that initially anger you. The really good stuff is likely to demand your reconsideration at a later date.

9. Be rigorous in your judgments and kind in your words.

10. Use your influence to make unlikely things happen.

11. Your independence is your integrity. Keep a respectful distance from dealers and collectors. But know also when exceptions are appropriate.

12. Be thorough in your research.

13. Do not trek only the usual art-world trade routes. Leave the herd from time to time.

14. Almost every exhibition is a team effort. Acknowledge the work of others, both publicly and privately.

15. Write clearly so that your texts are accessible to the average intelligent visitor. Let your language invite the reader in, not keep the reader out.

16. Ideally, curators of contemporary art are mystics rather than rationalists. They leap to conclusions that logic cannot reach.

Andrea Miller-Keller, born 1942, Los Angeles, U.S.
Current position: Independent curator and writer. **Former positions** include founding curator of *MATRIX, a changing exhibition of contemporary art* and Emily Hall Tremaine curator of contemporary art, Wadsworth Atheneum, Hartford; U.S. commissioner for the São Paulo *Bienal* (1996). **Selected exhibitions**: *Whitney Biennial* (co-curator, 2000, Whitney Museum of American Art, New York); organized more than 130 one-person *MATRIX* exhibitions at the Wadsworth Atheneum (including Janine Antoni, Judy Baca, Daniel Buren, Ian Hamilton Finley, Barbara Kruger, Cady Noland, Adrian Piper, Richard Tuttle, and Carrie Mae Weems). **Selected publications**: *Sol LeWitt: A Retrospective* (co-author, 2000, New York); *Sol LeWitt: Twenty-five Years of Wall Drawings* (co-author, Andover, 1993); brochures for the above-mentioned *MATRIX* exhibitions

Viktor Misiano

Curator-Moderator

Works by Dmitry Gutov, Jury
Leiderman, Vadim Fishkin, Anatoly
Osmolovsky, and Alexandr Brener
in *Conjugations*, Künstlerwerkstatt
Lothringerstrasse, Munich, 1995

Independent curatorial practice is not only an intellectual discourse, but also the ability to "see a work," and to conceive of an exhibition and organize it. Discourse, of course, is also produced by philosophers and theoreticians. Critics, gallerists, and collectors all can and must "see a work." Installing an exhibition is a job for exhibition designers. In addition to performing all of these tasks, the curator also has to find sponsors, and looking for money is no picnic. Even the artist will only attain success in tandem with the moves of his or her gallery.

Obviously, it helps if a curator is an intellectual with sharp vision, common sense, and social mobility. But that is not a prime condition for his or her success. What is the curator, anyway?

Let's start from another point: what is the artist? The artist today articulates subjectivity. His or her own ethnic and sexual identity, social position, infant traumas, secret recollections, private experiences, adult traumas, and so on are the artist's material. An artist no longer looks for a language of his or her own, but instead "creates" an identity. This route is complicated by the risk of being lost in the labyrinth of one's own identity and of losing the ability to relate to the outside world. Thus, the artist embraces a meta-level, a parallel dimension of the world, so-to-speak: the continuous global stream of information. Consequently, anybody who acts as a facilitator between

this artist and the art market, offers feedback on the work, or even provides new ideas enables the artist to help overcome an almost autistic situation and lets him or her feel at home in today's world of global exchange and information.

The curator fulfills the same function as this anonymous friend of our artist, but in addition provides another service: The curator moderates not so much the dialogue between artist and global information streams as he moderates the dialogue among artists, among their different subjectivities. This is the curator's most important task. Thus, whereas the artist today is mostly focused on him- or herself, the curator's focus is on the "other." Whereas the artist is occupied with "creating" a self, the curator is looking for the artist's humanity. In other words, the curator is looking less for good artists than for good people. The relationship between artist and curator is thus one of shared business interests, professional respect, and intellectual curiosity, but also friendship.

In my mind, friendship is not simply about mutual feelings but constitutes a unique type of social link. Perhaps it is the most fundamental of human links, putting the individual somewhere between solitude and community. To put it another way, the curator is not just manipulating signs and seemingly objective truths but rather is dealing with identities and relationships. Expected to produce a creative situation, he or she is well-versed in group communication. The curator is creating not only events, but communities and tribes. According to sociologists, friendship is a type of serial connection: The relationship between a gallerist and the artist is solidified by a contract (written or oral); the relationship between the artist and a museum is established when the museum purchases one of his or her works. The artist and the curator are doomed to separate, but when they meet again it seems that they have never been apart. New projects and new exhibitions, in fact, are created to make them meet.

Such a meeting constitutes curatorial discourse. While any theoretician is developing his or her thoughts from within, and while any critic works reactively to an exhibition, the curator is completely dissolved in the dimension of the here and now of the meeting with

the artist. It is the dialogue with the artist that yields the thought. In this sense, the curator is similar to a psychoanalyst: an exhibition project is a kind of group therapy. What I would like to witness is the exhibition that is a complete p.r. disaster—or one that doesn't open at all—yet will remain in the artist's memory as the most important event in his or her career.

If the relations between the curator and the artist are based upon friendship, personal qualities dominate professional qualifications. Consequently, the curator is usually reproached for his or her personality rather than professional achievements. Managers are fired for being inefficient, gallerists are cursed for being greedy, critics are lambasted for a lack of intellect, theoreticians are accused of being ignorant in their chosen field of expertise. It is the curator alone who is reproached for not being friendly or, worse, for being of bad character. Accordingly, famous curators are mostly nice people: it is impossible to imagine a curator (a successful one) who is unpleasant. And they must be seen: the curator's job presumes his or her physical presence, with the level of involvement determining one's "job approval." However, no matter how friendly they are, it has to end badly, for just as among friends, there can only be disappointment between curator and artist.

Viktor Misiano, born 1957, Moscow, Russia
Current position: Editor-in-chief, *Moscow Art Magazine*. **Former positions** include curator of contemporary art collection, State Pushkin Museum of Fine Arts, Moscow; director, Contemporary Art Center, Moscow. **Selected exhibitions**: *Cultural Differences: Production of a Chef-D'Oeuvre*, in Istanbul *Biennial* (1992); *Reason Is Something the World Must Obtain Whether It Wants To or Not . . .*, in Venice *Biennale* (1995); *INTERPOL* (1996, Fargfabriken Center for Contemporary Art, Stockholm); *Manifesta 1* (1996, Rotterdam, Netherlands); *L'autre Moitié de L'Europe* (2000, Paris). **Selected publications**: *INTERPOL: The Art Exhibition Which Divided East and West* (Stockholm, 2000); *The Institutionalization of Friendship* (Ljubljana, Slovenia, 1999); *Curator Without a System* (Madrid, 1998)

France Morin

Resistance and Healing Through Art

Works by Willie Cole, Larry Clark, and Cai Guo-Qiang in *The Quiet in the Land: Everyday Life, Contemporary Art, and Projeto Axé*, 2000

I have been in the art world since I co-founded the magazine *Parachute* in 1975 and had always worked in art institutions until 1994, when I decided to leave my position as senior curator at the New Museum of Contemporary Art in New York in order to push the limits of my profession, to work differently. After leaving the museum, I developed *The Quiet in the Land*, a series of multiyear contemporary art projects. I initiated this series in search of a new way of working that would reaffirm the potential of contemporary artists as catalysts of positive social change. This way would hopefully open up a language that would enable us to speak about the relationship between art and life from fresh perspectives, creating new definitions of such terms as "curator," "artist," "community," "residency," "work of art," "exhibition," and "publication." I also wanted to challenge our notions of categories themselves.

By creating situations in which artists and communities can work together to perceive both the differences that separate them and the similarities that connect them, these projects strive to activate the "space between" groups and individuals as a zone of potentiality. Fundamental to each project is a conception of art, rooted in the creative spirit that lies within everyone, as a powerful agent of both personal and social transformation.

The first project was organized in 1996, when I lived and worked for four months at the only active Shaker community in the world, in Sabbathday Lake, Maine, with ten artists, including Janine Antoni, Chen Zhen, Mona Hatoum, and Jana Sterbak. We experienced Shaker culture and its celebration of the aesthetics and sacredness of the activities of everyday life, and the artists drew on that experience to create works of art. *The Quiet in the Land* sought to probe conventional notions of gender, work, and spirituality; to redefine the making and experiencing of art; and to challenge the widespread belief that art and life exist in separate realms.

The second project in this series took place in 1999, when I lived for one year in Salvador, the capital of the state of Bahia, Brazil, with nineteen international artists and the educators and children of Projeto Axé, Center for the Defense and Protection of Children and Adolescents. The artists, who lived and worked in the city for six weeks at a time, included Janine Antoni, Chen Zhen, Cai Guo-Qiang, Larry Clark, Vik Muniz, Doris Salcedo, Rirkrit Tiravanija, Tunga, and Kara Walker, among others. Projeto Axé was established in Salvador in 1990 to address the devastating situation of the city's street children. It is founded on a philosophy of self-reliance, not charity, that involves the cultivation of ethics through aesthetics with the purpose of giving back to the children their dignity and equipping them with the tools they need to positively transform their lives. It is guided by the belief that an enriched life is about more than material well-being and that the impetus of artmaking is essentially spiritual.

The collaborations between the children and the artists gradually revealed the transformative potential of *The Quiet in the Land.* By reenchanting the world, by proposing that reality and poetry could be co-extensive, we discovered how it might be possible to reaffirm the dignity, beauty, and sacredness of every member of society, including the disenfranchised and the excluded; to instill the spaces and activities of daily life with the value traditionally ascribed to art; to reaffirm the social utility of art by reintegrating it with life; and consequently to initiate the process of social transformation, even if only on a modest scale.

Each project in *The Quiet in the Land* series unfolds over a period of at least three years. One of the reasons that these projects work is because of the commitment that the artists, the communities, and I myself make to them. This shared commitment, in which we immerse ourselves in the project, is the foundation for the close relationships that we develop and that nurture our work. To varying degrees, our work becomes our life, and this blurring of boundaries opens up new spaces of potentiality.

Working independently carries with it new responsibilities, but also new freedoms. As an independent curator, I am ultimately responsible for all aspects of each project, including fund-raising, research, and administration, and I must also work with extremely limited financial constraints. However, I have also discovered a great freedom in not having to carry the weight of an institution and its pressures on my shoulders. This freedom has enabled me to begin the process of forging the new curatorial vision that I was seeking when I decided to initiate *The Quiet in the Land.*

France Morin, born Montreal, Canada
Current position: Independent curator, New York.
Former positions include senior curator, New Museum of Contemporary Art in New York; director and curator, 49th Parallel, Center for Canadian Contemporary Art in New York; co-founder of *Parachute*. **Selected exhibitions**: *Heavenly Visions: Shaker Gift Drawings and Gift Songs* (2001, UCLA Hammer Museum, Los Angeles, traveling exhibition); *The Quiet in the Land: Everyday Life, Contemporary Art, and Projeto Axé* (2000, Museu de Arte Moderna da Bahia, Salvador, Brazil); *The Quiet in the Land: Everyday Life, Contemporary Art, and the Shakers* (1998, ICA, Boston); *The Interrupted Life: Issues of Death* (1991, New Museum, New York). **Selected publications**: *The Quiet in the Land: Everyday Life, Contemporary Art, and the Shakers* (New York, forthcoming, 2002); *Heavenly Visions: Shaker Gift Drawings and Gift Songs* (New York and Los Angeles, 2001); *The Quiet in the Land: Everyday Life, Contemporary Art, and Projeto Axé* (Brazil, 2000); *The Interrupted Life: Issues of Death* (New York, 1991)

Gerardo Mosquera

Eye, Mouth, and Ear

Work by Carlos Capelán in *Ante América*, Yerba Buena Center for the Arts, San Francisco, 1994

EYE. You cannot be a D.J. or a musicologist without an ear for music. Curiously enough, a postgraduate degree seems sufficient for working as a curator. However, a visual sensibility is the first thing you need to curate exhibitions. I am not talking just about sheer perception, but about an informed eye. Even if you can train your eye, you need a *de natura* aptitude to become that sort of visual D.J. that we call curator. Of course, there is not something like a "pure" gaze: your eye bears your own cultural, social, and personal experience.

MOUTH. Language is fundamental to communicate the meaning of an exhibition and the works it includes. Therefore, both the ability to speak and the ability to write are crucial components of the curator's job. As American art critic Harold Rosenberg noted more than fifty years ago, art is a centaur made half of words, half of artistic material, and words are the active element. Words were instrumental in differentiating art from handicrafts. But this has nothing to do with the "discourse inflation" that we are suffering from today. The recent curatorial boom has attracted people from other fields who frequently use art just as a base to build their ideas about something else. Another dangerous tendency among some curators is to use language's power to legitimate art just for commercial, political, or personal purposes.

EAR. To curate with the ears means not to rely on your eyes. It means to listen to the artists, to what has been discussed about their work, to situate it in its context. The ear is especially important in transcultural curating, because you need to learn and to react to art that might not correspond with your taste, knowledge, and experience. You have to open your mind to a plurality of languages and values. You have to be aware of the significance that artistic practices have in their original milieu, and also the probably dissimilar impact that they will have in different ones. Teamwork and Mikhail Bakhtin's notion of the dialogic are plausible here. In the age of globalization, curating should be an exercise of modesty, and the curator should be a cultural communicator.

Gerardo Mosquera, born Havana, Cuba, 1945
Current positions: Adjunct curator, New Museum of Contemporary Art, New York; adviser, Rijksakademie van Beeldenden Kunsten, Amsterdam, The Netherlands. **Former positions** include head of Department of Research, Wifredo Lam Center, Havana, Cuba.
Selected exhibitions: *It's Not What You See: Perverting Minimalism* (2000, Museo Nacional Centro de Arte Reina Sofía, Madrid, 2000); *Cildo Meireles* (co-curator, 1999, New Museum, New York); *Important and Exportant*, in Johannesburg *Biennial* (1997); *Ante América: Biblioteca Luis Ángel Arango* (co-curator, 1992, Bogota, Colombia, traveling exhibition); first, second, and third Havana *Bienales*, Cuba (co-curator, 1984, 1986, and 1989). **Selected publications**: *Fresh Cream: 10 Curators: 100 Artists* (London, 2000); *Beyond the Fantastic: Contemporary Art Criticism from Latin America* (London, 1995); *Contracandela* (Caracas, Venezuela 1995)

Fumio Nanjo

The Boredom & Excitement of Curating

Cai Guo-Qiang, *Bring to Venice
What Marco Polo Forgot*, in Venice
Biennale, 1995

Curating, broadly defined, is an art. As with any other profession, when it is done in a unique and creative way, it rises to the level of art. However, there is always a gap between what the curator says and tries to do, the goals he or she sets, and the final results seen in the exhibition. The curator's efforts never end and always fall short of the goal. That is because the curator must deal with real human beings as well as works of art, which are passive, inert objects. Curating is an expressive act performed by a human being within certain physical, economic, and temporal limitations.

Curating relies on sensibility as well as on rational thought. It is emotional as well as intellectual. It looks to ephemeral trends but aims at universality. It involves both visible and invisible elements. It makes statements but also refrains from speaking out. It is complex and full of contradictions.

Curating should not interfere with the intention of the artist and the art, nor should it force them into an overly restricted context. A curatorial concept is not a narrative. The curator does not make up stories, but merely comments on artist and art, taking a critical stance, a responsive position.

The curator's job is interesting and exciting, but care must be taken to avoid being overly authoritarian or self-satisfied. The best

antidote to this is extensive field research, since it helps ground the curatorial work in reality and provides a sound basis for the development of the curator's concepts. However, nothing significant can be achieved through field research alone. What is needed is a broader vision or, to put it another way, a sixth sense. The curator adopts a particular point of view, based on field research, and gives it form in an exhibition. He or she may not fully understand the works that end up on display, because it is not necessary to fully understand the art, only to probe its meaning, to be inquisitive about it. The curator must have intuitive insight and take certain risks. Otherwise, the exhibition will be limited, the manifestation of only that which he or she already knows.

The essence of curating, which lies beyond all this, is a kind of madness. To operate effectively, the curator must share the madness of the artist, a realm that he or she is just barely able to enter after making many judgments based on reality, which are a necessary evil. Madness gives meaning to curating, just as it does to art.

By the same token, the curator must firmly reject everything that is conventional and banal. Art only becomes art when it escapes convention. Therefore, curating is the task of building bridges between madness and conventional reality. The curator is a midwife, a translator, an accessory to crime, but it is a function neither desired nor requested by the artist. The curator is an isolated wanderer, welcomed by no one.

The artist may see the curator as a competitor and brutally cut him or her down. If this happens, the curator's life and nature are fulfilled in an ecstatic death. The curator embraces the artist/killer in the name of art, and the artist then becomes aware of having lost his or her best and most loving audience.

 Fumio Nanjo, born 1949 in Tokyo, Japan
Current position: Founder, Nanjo and Associates. **Former positions** include director, Institute of Contemporary Arts, Nagoya, Japan; officer, Arts Department of Japan Foundation, Tokyo. **Selected exhibitions**: *Mega Wave*, in Yokohama *Triennale* (co-curator, 2001); *Site of Desire*, in Taipai *Biennale*, Taiwan (1998); *Rei Naito*, in Venice *Biennale* (1997); *TransCulture*, in Venice *Biennale* (1995); *Of the Human Conditions* (1994, Wacoal Art Center, Tokyo); *Against Nature: Japanese Art in the 1980s* (co-curator, 1989–91, Grey Art Gallery, New York)

Hans-Ulrich Obrist

Battery, *Kraftwerk*, and Laboratory
(Alexander Dorner Revisited)

Andreas Slominski, *Untitled*, in *do it* (ICI traveling exhibition),
installed at Surrey Art Gallery (photo at left), British Columbia,
Canada, 1998, and Boise State University, Idaho, 1998

Alexander Dorner, who ran the Hanover Museum in northern Germany
in the 1920s, defined the museum as an energy plant, a *Kraftwerk*: he
invited artists such as El Lissitzky to develop new and dynamic displays
for what he called the "museum on the move." While operating in
the pseudo-neutral spaces dating from the nineteenth century and
prevalent at the time of his reign in Hannover, Dorner managed to
define the museum's functions in ways that are relevant today. His
importance—particularly for the young enrolled in curatorial-studies
programs these days—lies in his innovative definitions of the museum's
role. On various occasions, he spoke or wrote of:
• the museum in a state of permanent transformation
• the museum as oscillating between object and process. (Dorner:
 "The idea of process has penetrated our system of certainties.")
• the museum with multiple identities
• the museum as a pioneer, active, and not holding back
• the museum as relative (not absolute) truth
• the museum based on a dynamic concept of art history

- the "elastic museum," meaning a flexible display within an adaptable building
- the bridges to be built among artists, the museum, and a variety of scientific disciplines. (Dorner: "We cannot understand the forces which are effective in the visual production of today if we don't examine other fields of life.")

Classic, traditional exhibitions emphasize order and stability. But in our own lives, in our social environments, we see fluctuations and instability, many choices and limited predictability. Non-equilibrium physics has developed similar notions of "unstable systems" and the dynamics of "unstable environments." Likewise, the truly contemporary exhibition should express connective possibilities and make propositions. And, perhaps surprisingly, such an exhibition would re-connect with the laboratory years of twentieth-century exhibition practice, unearthing the "repressed" history of experimental exhibition design provided by such people as Herbert Bayer, Marcel Duchamp, Walter Gropius, Frederick Kiesler, El Lissitzky, Laszlo Moholy-Nagy, Ludwig Mies van der Rohe, and Alexander Dorner.

While we might readily acknowledge the importance of these historical ancestors of today's most vital exhibitions, what is to be made of Dorner's quest for "evolutionary/evolving displays," growth displays? If we consider the life of an exhibition as ongoing, we can view it as complex dynamic learning system—provided it comes with feedback loops that encourage voices of dissent. This will necessitate renouncing the closed, often paralyzing homogeneity of the traditional exhibition master plan. In other words, artworks would be allowed to extend tentacles to other works. The curator mustn't stand in the way of such growth. As you begin the process of interrogation—i.e., the research—the exhibition emerges. It would be an exhibition under permanent construction; the emergence of exhibitions within your exhibition; the self-generated exhibition. But such a time-based exhibition or museum would have to be created in relation to the sense of timing of the viewer, the time he or she spends in the museum.

Many of the new developments that I observe in curating are precisely related not only to space but also to the invention or re-invention of time in order to create new temporalities.

Regarding the exhibition's interior complexity, it could be nurtured less by actual objects than by events. Similar to the fantastic architecture of Piranesi's *Carceri*, the uneven structural elements of the exhibition would be intricate, with connections opening in all directions, an edifice strewn with non-linear paths that would allow every viewer to develop his or her own way. The traditional exhibition, which is essentially still modeled on Renaissance curiosity cabinets (*Wunderkammer*), usually causes sensory deprivation due to sensory overload. This truly contemporary exhibition with its striking quality of unfinishedness and incompleteness would trigger *pars pro toto* participation. The non-linear displays would allow the viewer to permanently create—and question—his or her own history, to find his or her own very own songlines.

Peeking into a related discipline, we see architect Rem Koolhaas providing us with strategies to embrace contradictions, to escape from paralyzing categories. He describes the necessity of coexistence of noise and silence, small and big, expensive and cheap, fast and slow. What he says about his recent museum projects is as valid for the curator's endeavor:

> The notion of a fast-track-touristic-trajectory through the
> museum does not allow for the return of slowness, or
> intensity. In the absence of a two-speed system, the museum
> experience in recent years has been accelerated for every-
> body. When you look at the beautiful era of New York's
> Museum of Modern Art's beginning, the "laboratory years"
> of the thirties, so to speak, you must acknowledge that you
> can't have a workshop situation visited by two million
> people a year. And that is why in our library and museum
> projects we try to facilitate the coexistence of the equivalent
> of urban noise experiences, and experiences that enable

focus and slowness. That is for me the most exciting way of thinking of the compatibility of mass visits and the core experience of stillness and being together with the work.

That, after all, is what is at issue when curating exhibitions.

 Hans-Ulrich Obrist, born 1968, Zurich, Switzerland **Current position**: *Migrateurs* curator, Musée d'art Moderne de la Ville de Paris. **Former positions** include founder of the Nano Museum and the Robert Walser Museum (traveling). **Selected exhibitions**: *do it* (1997–2001, ICI traveling exhibition); *Retrace Your Steps: Remember Tomorrow* (2000, Sir John Soane's Museum, London); *Cities on the Move* (co-curator, 1997–2000, Secession, Vienna, traveling exhibition); *Laboratorium* (co-curator, 1999, Antwerp, Belgium) *Life/Live, Nuit Blanche* (co-curator, 1998, Musée d'art Moderne de la Ville de Paris). *The Broken Mirror* (co-curator, 1993, Vienna Kunsthalle). **Selected publications**: *The Museum Is the Answer, What Is the Question* (forthcoming); editor of writings by Louise Bourgeois, Leon Golub, Gilbert and George, Maria Lassnig, Gerhard Richter, and others; editor of a series of artists' books by John Baldessari, Christian Boltanski, Gabriel Orozco, and others

Olu Oguibe

The Curator's Calling

Works by Olu Oguibe, Tracey Rose,
Kendall Geers, and Marcia Kure in
Crossing: Time, Space, Movement,
1997

Any meaningful discussion of the curatorial calling today must begin
by observing that there is a distinction between the curator whose
traditional job is to mind a collection, be it of art, clerical objects, or
zoological specimens, and the exhibition organizer or *commissaire,*
whose principal preoccupation is to assemble exhibitions. Lately it has
become customary, especially in the English-speaking world, to refer to
the latter as a curator, but it is a serious misnomer. Although responsi-
bilities may overlap on occasion between these two categories of cultural
practitioners, there are nevertheless significant differences between them.

No doubt many young people today are lured to "curatorial studies"
by the figure of the "international" exhibition organizer who puts
together pavilions for biennials and is believed to make or break artists'
careers. However, this dubious character is no more than an umpire
whose profession often necessitates the very antithesis of some of the
most fundamental requisites of the curatorial vocation. As a producer
of situations, a mere broker rather than custodian of culture, the exhibi-
tion organizer is often a shiftless careerist with only fleeting devotion
if any to the objects and artists that he or she assembles for display.

The origins of the curator's calling, unlike the exhibition maker's, lie
not in the glittery theaters of corporate museum marketing and fund-
raising, or the legerdemain corridors of show-business advertising, but

rather in the laity. The curate (the word "curator" has not yet appeared in most dictionaries)—the keeper of apostolic and iconic objects and documents—in turn derives her name from an even more loving profession, that of the nurse, who tends and cures: the caretaker. The curator's profession, therefore, is a caring one. To mind, nurse, or care for requires of caretakers that they love that which is in their care. They must be attached and devoted in order to perform their duty to satisfaction.

From devotion comes the effortless desire—which every good curator must possess—to study and research the material in his or her care with enthusiasm and thoroughness. They must delight in every opportunity to plumb the background, context, genesis, and circumstance of a work and its making, to seek to understand without presumption, to own the work as much as they are owned by it. In this regard curators are like monks, or better still, archivists or philatelists.

Equally indispensable is the gift of the eye—the otherwise inexplicable ability to discern enduring significance, or otherwise ephemeral beauty or relevance, in a work of art. The discerning eye requires an almost innocent openness to new knowledge, territories, revelations, and portals of discovery. The good curator must open herself up to the infinite possibilities of a work and its surroundings, to connections and relations beyond the contours of the obvious or readily discernible. It is this openness that enables the curator to successfully juxtapose seemingly disparate objects, artists, or indeed times and traditions to produce a good exhibition, when the occasion arises.

Since many who study to become curators may end up as mere exhibition makers even when they are employed in "curatorial" positions, a few words of guidance are perhaps in order.

While the job of the exhibition organizer may not require long-term devotion and attachment, it is nevertheless facilitated by a willingness to research and learn, and to pay more attention to the work of art and the artist than to career opportunism. Ignorance, narrow-mindedness, unmediated detachment, and lack of depth can only produce flawed exhibitions and a mediocre exhibition maker.

Another bane that derives from the above is trendiness, or the prevalent propensity among exhibition makers today to assemble celebrity names rather than pursue rigorous ideas or produce tasteful displays. The aspiring exhibition maker who has no desire to learn or make discoveries, and relies solely on college notebooks and art critics' columns for information or knowledge, is bound to end up in the rut of the *en vogue*. A good exhibition maker must be able to think independently.

Like the curator, the exhibition maker must possess the gift of the eye, perhaps not so much to discern the ultimate cultural weight of a work as to determine the interconnectedness of materials and objects at her disposal. In order to produce successful exhibitions, the organizer must have a good sense of space, linearity, and parallelism, and a fine grasp of conceptual and visual confluence. Like a good conductor, the maker of exhibitions must be primed in the principles of orchestration so that a thread is discernible in her assemblages, even when narrative is not.

Also, as cultural patronage becomes less dependent on institutions and traditional sources, exhibition makers would do well to acquire fund-raising skills in order to realize their projects in the form and scale of their aspirations.

Olu Oguibe, born 1964, Aba, Nigeria
Current position: Senior fellow, Vera List Center for Art and Politics, New School University, New York. **Former positions** include Stuart Golding Endowed Chair in African Art, University of South Florida. **Selected Exhibitions**: *Century City* (co-curator, 2001, Tate Modern, London); *Cinco Continentes y Una Ciudad: 3rd International Salon of Painting* (co-curator, 2000, Museo dela Ciudad de Mexico, Mexico City); *Crossling: Time. Space. Movement* (1997, Contemporary Art Museum, and Museum of African American Art, Tampa, Florida); *Pursuit of the Sacred: Evocations of the Spiritual in Contemporary African American Art* (1997, Betty Rhymer Gallery, School of the Art Institute of Chicago); *Seen/ Unseen: African Artists in Britain* (1994, Bluecoat Gallery, Liverpool). **Selected publications**: *Reading the Contemporary: African Art from Theory to the Marketplace* (Cambridge, Massachusetts, 1999); *Uzo Egonu: An African Artist in The West* (London, 1995); *Sojourners: New Writing by Africans in Britain* (London, 1994)

Apinan Poshyananda

The Acrobat, the Chef, the Go-between, and the Dreamer

Installation view of *Heri Dono: Dancing Demons and Drunken Deities*, The Japan Foundation Asia Center, Akasaka, Tokyo, 2000

In practice, when learning to walk on a tightrope, one should not be afraid of vertigo. Keeping one's balance and equilibrium in haphazard situations is essential for acrobatic acts.

Each chef de cuisine is skilled at making his or her special dishes. The epicure learns that gastronomy appeals to taste and smell, which are the oldest senses and the closest to the center of the mind. But not everyone likes unusual recipes such as monkey brain sushi or albino gecko soup.

The go-between is an intermediate agent who serves as a connecting link or bridge between individuals or groups. As a negotiator, at times he or she becomes a catalyst for those parties' different interests to overlap and intersect.

The dreamer fantasizes and travels on mind-journeys. Dream and fiction arouse creative imagination; but in reality, attempts at making personal dreams come true should not turn into someone else's nightmares.

The new breed of curators should acquire some of these abilities and precepts as part of their curatorial "survival kit." What helps mold and nurture the critical eye and intuition of a curator, apart

from what he or she learns in courses on curatorship, are personal experience, cultural background, and determination. Trust your own intuition. But in order to be sure of your instincts, your mind must always be alert and inquisitive. Achieving this level of awareness takes time, and valuable experience is gained by making mistakes and learning from them.

For more than three centuries, the English word "curator" has been in use as a noun referring to "someone in charge of a museum or other place of exhibit." Only during the last couple of decades has the verb "to curate" has become widely used. Meaning and interpretation of this verb are variable, resulting in curatorial hierarchies. Therefore, depending on who and where you are, the profession of curator can be regarded as prestigious or subordinate, to varying degrees. Some curators are behind-the-scenes organizers and cultural mediators, who scout new talents and are viewed as trendsetters. Others are cultural officers working in art institutions, part of the art infrastructure, whose job it is to make the institution function smoothly. Independent curators are frequently very dependent on institutions, galleries, artists, and sponsors.

In this age of a transnational and global art network, many curators live a nomadic life as they explore new territories. In the game of catch-up, the more informed and widely traveled curators tend to have an advantage and are often the ones who have the status of brokers of cultural goods, aesthetic arbiters, and gatekeepers. With an audience hungry for the cutting edge and the shock of the new, these curators are in a position to promote their own agendas, and even to dictate who is "in" and who is "out." At the same time, certain responsibilities come with global mobility, and curators involved in bringing art across borders must be sensitive to cross-cultural issues (including site, milieu, and manner of display).

Some words of advice for young curators: Take art seriously, but don't forget that human relationships are also important. According to the wisdom of the old Buddhists, words can be the most dangerous weapons of all. The art world is full of angels and villains, so it is

important to be able to distinguish between them. If you want to pursue this profession, you need to have some of the abilities mentioned above to make your curatorial career a long and productive one.

Apinan Poshyananda, born 1956, Bangkok, Thailand
Current position: Associate director, Center of Academic Resources, Chulalongkorn, Bangkok. **Former positions** include Asian commissioner for the São Paulo *Bienal.* **Selected exhibitions:** *Contemporary Art in Asia: Traditions and Tensions* (1996, Asia Society, New York, traveling exhibition). **Selected publications:** *Western Style Painting and Sculpture in the Thai Royal Court* (1993); *Modern Art in Thailand* (1992)

Mari Carmen Ramírez

The Creative Curator

Installation view of *Re-Aligning Vision*, Archer M. Huntington Art Gallery, Austin, Texas, 1998

The curator's allure today stems from his or her potential to actively mediate, broker, or translate the distance between public, private, corporate, and symbolic worlds. In the first case—that of the broker— the curator's function depends on his or her ability to openly negotiate the financial or symbolic status of everything from concrete artworks and artistic manifestations to the intangible identities of emergent cultures and new social movements. The second case—that of translator—implies decodifying cultural and artistic values from one context to another. The future success of curatorial efforts in this area will be largely dependent on the curator's adaptability and intelligent engagement of the processes dictated by these combined forces.

Despite these restrictions, or precisely because of the challenge they represent, curatorial practices, broadly understood, have come to embody one of the most dynamic forms of cultural agency available today. Its intrinsic mobility—throughout and in between institutional, private, corporate, and public sectors—endows it with the potential to affect a series of interdependent areas in ways not accessible to other more restricted modes of cultural practice. From this point of view, curators are not only helping to redefine the site, the audience, and the nature of the art experience itself, but are even participating in community-building efforts. Therein undoubtedly lies the critical

potential of these practices to radically impact the social conditions in which they are inscribed.

Despite positive gains in visibility and influence, the downside of the already mentioned shift lies in the ongoing erosion of the creative potential of curatorial practice, and its intellectual diminution to an instrumental role strictly facilitating and/or promoting private or institutional interests. As Olivier Debroise has pointed out, ours is a practice involving mostly the production of meaning by means of exhibitions or other creative endeavors. Meanings are not only critical for the continued nourishment and development of art, but for its positive impact in a democratic society. In my view, it is in this particular area that the gains and losses of the new curatorial roles must be duly assessed and their future potential mapped.

I believe that curatorial practice entails a creative and imaginative dimension that is somewhat parallel to that of the artist and even closer to that of the critic. This is not to say that the curator should take the artist's place, as some recent detractors have naïvely suggested. Rather, it implies acknowledging that curatorship involves a propositional discourse that invariably results in some form of "scenic enunciation," whether by means of an exhibition or other concrete manifestation of the curatorial proposal. One of the primary aims of this type of proposal should be to displace the fixed values of the "well-known" in order to establish the "unknown" or "scarcely known" as a new potential value. This type of curatorial practice inherently involves criticism as well as the deliberate questioning of any form of entrenched, official, or canonical discourse, art history included. Additionally, the idea of "scenic enunciation" suggests a temporary space—whether in the museum, the gallery, or the city—for revealing links among artists, works, or other cultural phenomena that are inverted, displaced, and in critical tension.

Paradoxically, for artists as well as for the community, this perspective puts forth a more critical and dialogic vision that is more participatory and interactive. For example, many artists today use multimedia, performance, and installation art to respond to the propositions, themes, or problems posed by curators. This type of

interplay presupposes a relationship between curator and artist which, in turn, renders the relationship between the artwork and the social context—and ultimately between the micro and macro narratives of the social and political order—more flexible. Additionally, this interactive notion also implies that the curator must be allowed to produce theoretical frameworks from the stimula provided by art.

What must be stressed, however, is that the full potential of these practices cannot evolve inside the institution of the museum, at least as it is understood today. Instead, they must either engage in re-inventing the institution or must step outside its parameters in order to recapture the public site for art in the twenty-first century.

To sum up: What I am arguing for is the idea of a creative curator who produces theory through his or her praxis—a theory that is embodied, not illustrated, by the curatorial act itself. I believe that in our mediated society, it is time that we concretely envision the full potential of this type of immediate operation.

 Mari Carmen Ramírez, born Puerto Rico, U.S. **Current position**: Curator of Latin American Art, Museum of Fine Arts, Houston. **Former positions** include curator of Latin American Art, Jack S. Blanton Museum of Art; director, Museum of Anthropology, History and Art, University of Puerto Rico, Río Piedras. **Selected exhibitions**: *Heterotopias: Medio Siglo Sin Lugar* (2000–2001, Museo Nacional Centro de Arte Reina Sofía, Madrid); *David Alfaro Siqueiros*, in São Paulo *Biennal* (1998); *Re-Aligning Vision: Alternative Currents in South American Drawing* (1997–99, El Museo del Barrio, New York, traveling exhibition); *Universalis*, in São Paulo *Biennal* (co-curator, 1996); *The School of the South: El Taller Torres-García and Its Legacy* (1991, Museo Nacional Centro de Arte Reina Sofía, traveling exhibition). **Selected publications**: *Cantos Paralelos: Visual Parody in Contemporary Argentinean Art* (Austin, 1999); "Brokering Identities: Art Curators and the Politics of Cultural Representation," in *Thinking About Exhibitions* (London and New York, 1996); "Blue-Print Circuits: Conceptual Art and Politics in Latin America," in *Latin American Art of the Twentieth Century* (New York, 1993)

Lawrence Rinder

Curatorial Cool

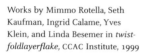

Works by Mimmo Rotella, Seth Kaufman, Ingrid Calame, Yves Klein, and Linda Besemer in *twistfoldlayerflake*, CCAC Institute, 1999

Curating has become cool. Students who once would have pursued degrees in Cultural Studies or Critical Theory, which in recent years were considered chic, now lean toward the new academic field of Curatorial Studies. It has become commonplace for artists to list not only the titles of exhibitions on their resumés, but the names of the curators as well. It once was a mark of honor to have work "exhibited"; now artists speak with pride of having been "curated." I have even heard one aspiring curator speak of her desire to "curate" a particular work, as if curating were some kind of singular benediction conferred by this recently academicized priestly caste upon a select coterie of worthy objects. The notion of curating has become unmoored from its prosaic meaning of organizing exhibitions and has come to define a highly specialized but worryingly imprecise practice of arbitrating not only taste but also politics, sexuality, and ethnicity. To be a curator is to be in the catbird seat of culture.

All of which makes me concerned that curators are in danger of taking themselves a bit too seriously. The proliferation of Curatorial Studies programs, Curatorial conferences, and Curatorial internet chat groups has had many productive effects; however, it has also exacerbated a tendency toward self-importance and navel-gazing. As curating becomes ever more academic and curators become increasingly visible and celebrated, we are in danger of forgetting that our work is dependent upon

and—in my opinion—in service of the more important and nobler work of creative artists.

My concerns should not be mistaken for a bias against socially engaged or activist curators. I regard the exhibitions of Group Material, for example, as some of the most important curatorial work of the late twentieth century. Their complex projects interweaving art, popular culture, and fastidiously researched information went further than nearly any other curatorial practitioner in proving the urgency of the art of our time. In a related vein, Catherine David's *documenta 10* profoundly contextualized the art of the past thirty years in terms of urbanism, economics, and global politics. Curatorial projects such as these, however, succeeded because the curators who organized those exhibitions maintained a crucial humility before the artworks in their care. Their work began and ended with art, measuring its success by the degree to which the artworks involved were allowed to do *their* work.

Curating is a service profession, not a bully pulpit. The more curators can be transparent to the work they serve, the better their exhibitions will be. Art, thankfully, plays a unique role in our lives: it can never be wholly contained by definitions, nor can its purpose ever be summarized. Yet it is the very power of art's excess that is in danger of being forgotten as the curatorial burden falls increasingly on the "smart" exhibition concept, or of being overshadowed as curators themselves become the art stars of the moment. It is time for curators to settle down and let the art and the artists take center stage.

 Lawrence Rinder, born 1961, New York City, U.S.
Current position: Anne and Joel Ehrenkranz curator of contemporary art, Whitney Museum of American Art, New York. **Former positions** include director, California College of Arts and Crafts (CCAC) Institute, Oakland and San Francisco, California; curator for twentieth-century art, Berkeley Art Museum, California. **Selected exhibitions**: *BitStreams* (2001, Whitney); *Searchlight: Consciousness at the Millennium* (1999, CCAC Institute, San Francisco); *Louise Bourgeois: Drawings* (1996, Berkeley Art Museum); *In a Different Light* (1995, Berkeley Art Museum); *Theresa Hak Kyung Cha: Other Things Seen, Other Things Heard* (1992, Whitney). **Selected publications**: "Painting Around the Fire: Maisin Culture and Collectivity," *Art Journal*, 57, no. 2 (Summer 1998); "Anywhere Out of the World: The Photography of Jack Smith," in *Flaming Creature: Jack Smith* (New York, 1997); "Tuymans' Terror," in *Premonitions: Luc Tuymans, Drawings* (Bern, 1997)

Mark Rosenthal

Leave the Art Alone!

Works by Piet Mondrian, Kasimir
Malevich, Richard Serra, and others
in *Abstraction in the Twentieth
Century*, 1996

Visitors to a museum do not come to hear the "voice" of a curator
but that of an artist. This profound truth should never be forgotten
by the curatorial profession. We are facilitators, even impresarios,
but our ideas about art will never enthrall a viewer the way a single
work might. Our fundamental task is to make certain that we install
each work of art so that it, and hence the artist's viewpoint, is seen
to best advantage.

Art is, happily, still not archaeology. Yes, an art object possesses
characteristics that link it with a specific historical period, locale,
culture, and even gender. However, the average museum visitor is
most interested in the aesthetic experience—the pleasure of looking
at art. That is what is possible and desired in a museum, as opposed
to what can be learned from reading. The curator must keep this
premise paramount: that the work remains something of a holy
presence, more than an artifact.

The curator's first responsibility, after the respectful presentation
of the object, is to the general public, not to our colleagues in the art
world. This is not to minimize the fact that we are active participants
in the art world, only that our jobs in museums address a much
broader audience. We should be thinking about the creation of art
lovers, who will hunger for the direct experience of the work of art—

an experience that is provided, above all, in a museum. If we act with this responsibility in mind, we ensure the future of both art and the museum.

Where can the curator's ego be given voice? Where can his or her ideas be expressed? Aside from a catalogue, the primary vehicle for them is a theme show. However, if the theme is not sufficiently neutral to allow the individual works to sing, the works will function merely as illustrations. Given the museum context, the curator's point of view is expressed, most of all, in the selection of artists and works for exhibitions. In this activity, we offer a provocation to the general public and to the art world to consider our convictions and passions.

Mark Rosenthal, born 1945, Philadelphia, Pennsylvania, U.S.
Current position: Senior vice president, international director for 19th- and 20th-century paintings department, Christies, New York. **Former positions** include curator of twentieth-century art, Solomon R. Guggenheim Museum, New York; head of department of twentieth-century art, National Gallery of Art, Washington D.C.; consultative curator, Guggenheim Museum. **Selected exhibitions:** *Picasso: The Early Years, 1892–1906* (1997, National Gallery, traveling exhibition); *Abstraction in the Twentieth Century* (1996, Guggenheim Museum). **Selected publications:** *Jasper Johns: Work Since 1974* (Philadelphia, 1988); *Anselm Kiefer* (Philadelphia, 1987)

Irving Sandler

Letter to a Young Curator

Works by Sol LeWitt, François
Morellet, Carl Andre, Donald
Judd, and others in *Concepts in
Construction*, Neuberger Museum,
State University of New York at
Purchase, 1985

Dear beginning curator,

 I've been asked by ICI to advise you on the basis of my experience
as a curator. Not only have I organized a considerable number of
shows in the past four decades but equally important, I have served
for many years on the exhibitions committee of ICI and have consid-
ered dozens of proposals.

 What is the most important piece of advice I can offer you?
Simply, determine the need for the show you want to do. What is its
relevance? Why do it now? Certainly, you must be guided by your
own emotional and intellectual desires and interests, but then you
must provide a persuasive rationale for your show, if only because it
must get the approval of others.

 What kind of shows do I think would be the most relevant at
present? In this period of rampant pluralism, there is a need to
identify the issues and clarify them through exhibitions. The most
useful shows then are thematic. Curate for now!

 How should you develop your curatorial skills? On the basis of
my experience, I would recommend, in order of importance, seeing
as many shows as you possibly can; following art criticism; trying to
fathom the leading aesthetic and social issues of our time; and (last
of all) reading art history.

For whom should you curate? Above all, for the art world—that is, for art-conscious people. Be aware, however, that you can reach the broader public in your catalogue introductions and wall texts. The trick is to write clearly so as to be understood by the average educated viewer. The most successful art writing is that which is both of interest to the art-knowledgeable audience and to the general public. Unclear writing is a sign of sloppy thinking. Above all, avoid glittering generalities—what a mentor of mine, Thomas Hess, called "glidge."

Sincerely yours,
Irving Sandler

Irving Sandler, born 1925, New York City, U.S.
Current position: Professor emeritus, State University of New York, Purchase. **Former positions** include art critic, *New York Post*; co-founder of Artists Space, New York. **Selected exhibitions**: *After Matisse* (co-curator, 1986–88, ICI traveling exhibition); *Concept and Construction* (1983–85, ICI traveling exhibition); *The Prospect Mountain Sculpture Show: An Homage to David Smith* (1979, Lake George Arts Project, Lake George, New York); *Sculpture in Environment* (1967, New York); *Concrete Expressionism* (1965, New York University). **Selected publications**: *Art of the Postmodern Era: From the late 1960s to the Early 1990s* (New York, 1996); *American Art of the 1960s* (New York, 1988); *The New York School: Painters and Sculptors of the 1950s* (New York, 1978); *The Triumph of American Painting: A History of Abstract Expressionism* (New York, 1970)

Jérôme Sans

Exhibition or Ex/position?

Nari Ward, *Buy Black*, in *Streetlife*, 1999

According to German art historian Werner Hoffmann, the exhibition should be a "work site of ideas, "a construction site that each time attempts an analysis of the exhibition apparatus, suggests new openings, solicits questions, launches debate. Conceiving the exhibition as a work site implies possible developments. A curator's exhibitions should, like the rooms of a well-planned museum (in the sense of Alexander Dorner's accomplishments at the Hannover Landesmuseum in the 1920s), be thought of as chapters in a book unfolding in a coherent and precise fashion from room to room, from show to show, over the years. They should be like chapters of an ongoing book. This doesn't mean a tireless repetition of the same discourse or the same group of artists or an exclusively programmatic vision; it simply suggests the value of having a real connecting thread. But this work site can only be a success through the collective enterprise that it implies, an enterprise shared by the curator and the artist (or artists) whose works are being shown.

An exhibition is a place for debate, not just a public display. The French word for it, *exposition*, connotes taking a position, a theoretical position; it is a mutual commitment on the part of all those participating in it. The adventure of making an exhibition is similar to the collaborative making of a film. For the filmmaking to succeed, it is

better that each actor and technician know not only his or her own role but everyone else's. It is an enterprise that should be shared by everyone or not undertaken at all.

I have always preferred exhibitions that allow for the adventure of the art itself—not only the adventure of works created specifically for the occasion but, more important, the adventure at the very heart of the artist's oeuvre. The exhibition as adventure invites the artist to venture into new, unexpected territory; the exhibition as an experimental site is as nomadic as the work itself. We can understand why, despite common practice, it is so difficult to produce successful exhibitions of the work of deceased artists, or even of the work of living ones without their active participation.

Jérôme Sans, born Paris, France
Current positions: Co-director, Palais de Tokyo, Paris; adjunct curator, Institute of Visual Arts, Milwaukee, Wisconsin. **Selected exhibitions**: *My Home Is Yours, Your Home Is Mine* (co-curator, 2000–01, Samsung Museum, Seoul, traveling exhibition); *The Sky Is the Limit*, in Taipei *Biennial*, Taiwan (co-curator, 2000); *The Snowball*, Danish Pavilion, Venice *Biennale* (co-curator, 1999); *Pierre Huyghe* (Serralves Museum, Porto, Portugal, 1999); *Streetlife* (Project Row Houses, Houston, Texas, 1999); *Shopping* (New York, 1996). **Selected publications**: *Araki by Araki* (Ostfildern, Germany, 2001); *Jonas Mekas: Just Like a Shadow* (Göttingen, Germany, 2000); *Daniel Buren: Au Sujet De* (Paris, 1998)

Ingrid Schaffner

"Shut Up and Look"

Works by Richard Artschwager,
Annette Messager, Jason Rhoades,
Christo, and Wilhelm Mundt in
Deep Storage, Haus der Kunst,
Munich, 1997

"Shut up and look" is advice that comes to me from artist Richard
Artschwager. He says it kindly, and I agree with the sentiment and so
I pass it along to beginning curators. Obviously, look at as much art
as you can. But more relevant to curatorial practice, look at exhibi-
tions. Whatever the organizing principle or effect—narrative, theater,
laboratory, lounge—all exhibitions are constructs. You can get some
sense of what you have to build with if, when visiting your next one,
you ask: How does the show open—with a declaration, a tease? What
is the mood—thoughtful, energetic, chaotic, soporific? What is the
spatial relationship of one work to the next—intimate, claustropho-
bic, generous, remote? How are works organized? Are they treated
primarily as formal or as conceptual objects? How do they illuminate
or expand upon the curatorial premise? Are the walls painted? If so,
what color? Does the installation enhance or interfere with the
objects on view? What about signage: What does it look like? How
does it read, whom does it address? Is there a brochure or catalogue,
and is it general or scholarly reading? How does the exhibition end—
does it trail off, finish with a bang, or lead to a gift store? Finally, did
the exhibition deliver on its title, its premise, its p.r.? For the curator,
each of these questions (and there are plenty more) represents a
problem, a decision, and something to play with.

I got started answering these questions for myself through the Whitney Museum of American Art's Independent Study Program, a think tank for young curators and artists. The Whitney program encouraged us to be critical about our respective practices, and stamped me for a career that has developed not in a museum but outside it—as an independent curator. The difference points to one of the major changes in the role of curator in the past twenty-five years—namely, voice. My work largely involves looking at contemporary art to talk about alternative or marginalized histories, especially in terms of Surrealism. For example, my exhibition *Deep Storage* (1998) looked at images of storing, archiving, and collecting in recent art to recount a new way of unpacking the images and ideas in the work of Marcel Duchamp, Joseph Cornell, Eugène Atget, and Aby Warburg, among other early moderns. I don't know that I would have been able to develop this premise had I been working in an institution. But now, with this *Vade Mecum* as perfect proof, we are beginning to look to exhibitions for a point of view and to see curators—both in and outside the museum—as authors, perhaps even as creative operatives in their own right.

Ingrid Schaffner, born 1961, Pittsburgh, Pennsylvania, U.S. **Current positions**: Independent curator and writer; recently appointed adjunct curator, Institute of Contemporary Art, University of Pennsylvania, Philadelphia. **Selected exhibitions**: *About the Bayberry Bush* (2001, Parrish Art Museum, Southampton, New York); *Pictures, Patents, Monkeys, and More . . . On Collecting* (2000–2003, ICI traveling exhibition); *Deep Storage: Collecting, Storing, and Archiving in Contemporary Art* (1997–98, Haus der Kunst, Munich, traveling exhibition); *Julien Levy: Portrait of an Art Gallery* (1998, Equitable Gallery, New York); *Pop Surrealism* (co-curator, 1998, Aldrich Museum of Contemporary Art, Ridgefield, Connecticut); *The Return of the Cadavre Exquis* (1993, The Drawing Center, New York). **Selected publications**: "Circling Oblivion: Bruce Nauman through Samuel Beckett," in *Bruce Nauman* (Ridgefield, 1997); "A Short History of [Richard Artschwager's] blp," *Parkett*, no. 46 (1996); "Marlene Dumas's Pornographic Mirror," *Parkett*, no. 43 (1995)

Paul Schimmel

Play Favorites

Works by Chris Burden and Llyn
Foulkes in *Helter Skelter*, 1992

Since I first began curating twenty-five years ago, the demand for
contemporary art has increased, but the essential elements of the
curatorial profession remain pretty much the same. In fact, the single
most important responsibility of a curator is as clear now as it was
in the 1970s: to contextualize art according to the artist's own vision,
experience, and intent.

Young curators can easily confuse themselves into thinking that
what they have to say about a work of art, the context they put it in,
and the audience that they bring to it are equally as important as the
object itself. But, this just isn't true. Even if you are a brilliant critic
and have the foresight to anticipate the prevalent discourse a decade
or two down the road, your contribution will always be much less
significant than the work of art itself. Great works live on in spite of
the discourses and exhibitions (and the abuses that go along with
them) that bring art to a larger audience. Our first responsibility
when working with art made by living artists is to the artists them-
selves. Curators, art historians, and critics may apply new museological,
critical, and art-historical tastes and fashions to a work of art, but the
artist's own vision is timeless.

As a curator of contemporary art, the closer you are to the source
of the art object, the more you can appreciate its primacy and the

unique responsibility that you have to make a direct link between it and the artist's vision. Before we think about re-contextualizing a work of art, our first responsibility is to ensure that it is contextualized as the artist would have it. Curators need to bring forward options in a clear and forceful manner to help artists develop and participate in their own public reception.

As a young curator, I was fortunate to be given the opportunity by James Harithas, then director of the Everson Museum in Syracuse, to work directly with artists. Through my friendships with Norman Blum, John Chamberlain, and Julian Schnabel (among others with whom I worked during the mid-1970s), I learned that you not only have to look at the work and imagine how it can be most responsibly exhibited, but you have to listen to the artist. The most important thing that you can do as a curator is to select the right artist at the right time in his or her career and provide the resources that he or she needs.

You will never pick the right artists at the right time if you think you will find the answers in journals, museums, and commercial galleries. Instead, be a leader. Abandon the whole notion of distance from the creative community—don't stand aside, and don't put yourself above. Don't try to be fair or impartial. Be passionate, committed. Play favorites, and most important, never use works of art as illustration.

The kinds of exhibitions that we need today are not so different from what we've needed all along: generous, thoughtful exhibitions dedicated to those artists who are both deserving and underrepresented. Given all the venues and opportunities that exist for the artist, it is shocking how many shows are done with so few, and how the same artists appear again and again everywhere. This makes for unoriginal exhibitions, and has a detrimental effect on the artist's ability to move forward in the creation of new work.

At this stage in my career, the exhibition I would most like to curate is the one that would allow artists to show on a level playing field with the best work being done in architecture, new technology, commercial filmmaking, etc. I think, at least for the moment, we are giving increased weight to the exhibition context—whether it be a

new museum, a blockbuster, or an international exhibition—than we give to the development of new works.

Perhaps for my own job satisfaction, I have always tried to mix the kind of exhibitions I do. I have worked on historical shows and also on contemporary retrospectives of artists such as Chris Burden, Charles Ray, and Sigmar Polke. I have worked on little exhibitions and on big thematic exhibitions such as *Public Offerings*. It has always been invigorating to go back and forth in time, up and down in scale, from monographic to thematic, to avoid becoming overly proficient or cynical about the type of exhibitions one creates.

I believe in museums and their slow (some might even say excruciating), ponderous ways. Museum curators can never show new work faster than a gallery, nor can we be more critically visible than an art journal. We cannot be on the cusp of every zeitgeist. What we can do is make a lifetime commitment to an individual artist; we can develop exhibitions and a permanent collection simultaneously; we can create a base of collectors and institutional support that provides a real freedom for an artist and a museum to achieve originality.

Paul Schimmel, born 1954, New York City, U.S.
Current postion: Chief curator, Museum of Contemporary Art (MOCA), Los Angeles. **Former positions** include chief curator, Newport Harbor Art Museum, Newport Beach, California; senior curator, Contemporary Arts Museum, Houston. **Selected exhibitions**: *Public Offerings* (2001, MOCA); *Charles Ray* (1998, Whitney Museum of American Art, New York); *Out of Actions: Between Performance and the Object, 1949–1979* (1998, MOCA); *Robert Gober* (1997, MOCA); *Hand-Painted Pop: American Art in Transition, 1955–1962* (co-curator, 1992, MOCA, traveling exhibition); *Helter Skelter: Los Angeles Art in the 1990s* (1992, MOCA); *Chris Burden: A 20-Year Survey* (1988, Newport Harbor Art Museum). **Selected publications**: *Hand-Painted Pop: American Art in Transition, 1955–62* (Los Angeles, 1992); *Chris Burden: A 20-Year Survey* (Newport Beach, 1988); *Objectives: The New Sculpture* (Newport Beach, 1988)

Jana Ševčíková and Jiří Ševčík

Morality for Curators

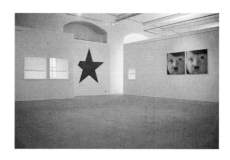

Works by Ivan Vosecky, Vladimir
Skrepl, and Jiri Suruvka in *The Art
of Survival*, Castle Plassenburg,
Kulmbach, Germany, 2000

Always do only what interests you and what you believe in. Curating
is like any other art form: it only serves to express your relationship
to the world. No objective rules apply; there is not even a stable hier-
archy of values to guide you. The meaning of images is never anchored
by any kind of objective truth. You must not fall for the illusion of
such truths, and instead propose questions challenging your own
assumptions and especially the norms of the cultural establishment—
if possible, questions that seem useless or impossible to answer. This
is the only way you can develop new relationships and provoke lively
conflicts for which there exists no common denominator.

Don't get trapped in the past—do exhibitions that are in touch
with the present. Even in historic exhibitions, it is necessary to
maintain the tension between the past and the present. There is no
guarantee of truth in historic material, or its completeness either. In
fact, you have no access to "truth" other than the subjective "truth"
filtered through your own individual mind-set, and colored by your
own experience and your current situation.

Try sometimes to curate group exhibitions involving large numbers
of artists. This will get you interested in a variety of different strategies
and in trying to understand the work of many individuals. Organizing
an exhibition is most thrilling when it seems to be difficult to manage

it as a whole. And hold onto the meaningfulness of each piece. If you don't know exactly why you chose the works you did, and if they don't support one another or don't produce the right conflict with one another, you won't have a good exhibition. The measure of a good group exhibition is when the viewer who does not remember individual works leaves with the feeling that it was about something.

The most important thing to realize is that you curate for yourself, and you are responsible only to yourself and to what you believe in. Of course, you won't be able to explain that to your host institutions; and if you stick to such a philosophy, you may find yourself without sponsors. But regardless, never back away from it.

It will happen that some of your exhibitions will be misunderstood. What is important to keep in mind is that, despite this, your exhibitions will have an impact and that the underlying ideas will be apparent to some, if not all, of your audience. Try to learn to entice viewers with something other than aesthetics. Art involves more than just its aesthetic components, and must concern itself with more important things than beauty.

Learn to make exhibitions that don't require much money, with low overhead and inexpensive materials. That way, you gain greater independence and you learn to work in alternative spaces that are good points of departure and, in the end, often good refuges from established culture. You must know how to work decentralized and function locally.

Don't conserve art—that's not the role of a curator, although sponsors, institutions, employers, and audiences will curse you if you don't give a prominent role to past art. Sometimes it's not enough just to exhibit art; sometimes it's more important to reveal the context in which the art has been created, or to try to change the framework in which the entire cultural production is seen. Never trust completely depoliticized culture, and always believe that art can cause something—that it is not an end in and of itself, but is often only a point of departure.

You gain the ability to curate by knowing many things, but not only from your particular field of expertise. Understand your work as

part of a larger body of activities, which by your efforts you only add to—but try to maintain your independence. There is not just a single linear scale of values. You must find an understanding of and a way to acknowledge every difference; otherwise you sacrifice important things to the laughable superiority of a single ruler. A key to being a successful curator is to take advantage of circumstances. In our case, local exhibitions that we did for people in uncertain social and political situations—exhibitions with metaphoric names such as *That Which Was Left, Test Run, Lowered Budget, Second Exit, The Art of Survival*— were the most important, but they hardly helped anyone from abroad understand these social and political situations, nor understand the art, for that matter.

Curators should work without limitations, but should not use their mobility to simply "pick up the raisins for their own cake," whose recipe in the first place is provided by their surroundings. Perhaps it makes the most sense not to remove contradictions and correct so-called bad examples (the "raisins" that taste bitter or sour) but to smuggle unfamiliar problems and unfamiliar suffering into our curatorial language. That way, we ourselves—and through our exhibitions, the public—can live these different experiences.

 Jiří Ševčík, born 1940, Jablonné nad Orlicí, Czechoslovakia **Current positions:** Dean of research and international relations, Academy of Fine Arts, Prague; and independent curator. **Former positions** include director of the Collection of Modern Art, National Gallery, Prague; curator of Municipal Gallery of Prague

Jana Ševčíková, born 1941, Prague, Czechoslovakia **Current positions**: Docent of post-war history of art, Academy of Fine Arts, Prague, independent curator. **Former positions** include curator of National Gallery, Prague.

Selected exhibitions (jointly): *Art of Survival: Contemporary Czech Art* (2000; Neuer Berliner Kunstverein, Berlin, traveling exhibition); *Distant Similarities— Something Better than Cosmetics* (1999, National Gallery, Prague); *Reduced Budget* (1997, Manes, Prague); *Second Exit* (1993, Ludwig Forum, Aachen, Germany); *Contribution to Happiness* (1991, Galerie der Kunstler, Munich); *Czech Painting Today* (1989, Galerie der Stadt Esslingen, Germany); *Description of a Struggle* (1989, Gallery of Fine Art, Cheb, Roudnice nad Labem, Karlovy Vary)

Seth Siegelaub

Notes Toward a History of Independent Curating, or The Last Picture Show and the First Independent Curator

Works by Douglas Huebler (on windowsill), Lawrence Weiner (stain on rug), Robert Barry (labels on wall), and Joseph Kosuth (newspapers on wall) in *January 5–31, 1969*, 1969

The world of contemporary art has changed dramatically, and with it, the role of the curator. Once upon a time, before the mid-1960s, the art world was smaller, poorer, simpler, and more marginal; everybody's role was clear and more-or-less well-defined: the artist made art, the art critic wrote about art, the gallery promoted and sold art, the collector collected art, the museum stored and showed art, and the curator curated. The concept and practice of the curator was embedded in this reality. Basically, the curator was a salaried employee working for the museum. Between World War II and the mid-1960s, this was usually a (white) woman from a "good" background, often underpaid (men, "naturally," were directors), who functioned as a bridge between the power of the rich collector (via the museum) and the rest of the art world.

During the last forty years, the art world has gradually shifted from its traditional "ghetto" and "bohemian" status on the periphery of capitalist society closer to its central values, as art—contemporary art as well as older art by Vincent van Gogh and other "name" artists—has become an acceptable part of modern society's cultural life and entertainment. This shift has been accompanied by an expanded interest in art by the government, business, media, and the public, necessitating more of everything: more artists, more galleries, more

art critics, more art advisers, more art schools, more art restaurants and bars, more art lovers, more art collectors, more collections, more exhibitions, more museums, and, with these, the need for more art curators.

This has gradually transformed the traditional museum from a "private" club for rich collectors and their "employees" into a "semi-public" business enterprise involving a multitude of commercial activities and new agendas, especially in the United States: corporate sponsorships and tie-ins; gift shops, restaurants, tee-shirts, postcards, datebooks, and calendars; membership marketing; the striving for high attendance and "blockbuster" exhibitions; the museum as part of a city's or state's tourism policy; the museum as "modern" architecture, real-estate development, and investment; and so on. These efforts to create a more "businesslike" museum environment have led to attempts to reduce fixed overheads, especially labor costs, including the "un-profitable" intellectual art curator. Not surprisingly, such developments have changed the nature of curating, not least of all by lowering the critical intellectual level of most exhibitions, as well as shifting the work of the curator toward more administrative tasks, including fund-raising.

Simultaneously in the mid-1960s there was also a growing political change: a generalized heightened critical consciousness due to the larger struggles of the period—in the U.S., for example, the anti–Vietnam War protests, student activism, etc.—forcing everyone in an art-related profession, including curators, to question their role in the art-world "scheme of things" and the general "power structure." Fundamental to the changing role of the curator were the new art forms that also arose in the mid-1960s (forms that were made in large part in critical response to these greater sociopolitical issues), especially what is now known as Conceptual art, but also *arte povera*, land art, video art, new forms of photography, and others, all of which questioned the very need for the traditional museum as exhibition space and as an institution. These new art forms opened up a completely new range of possibilities for the creation, exhibition, communication, and consumption of art. Many of these possibilities

were directly linked to the new means of art production and distribution, which made such art inexpensive to produce and transport: "mail art"; the inexpensive "shipping" of the artist for the creation of on-site works instead of the expensive shipping of "pre-fabricated" paintings and sculpture; art as "public property" instead of as a unique object and private commodity; art as a living process and not necessarily an eternal object. These and other new approaches posed a potential for opening up of all aspects of art, including a new active relationship to the public.

These new possibilities would provoke a complete re-thinking of the domination of contemporary art as an exclusively white, male, "Western" activity, creating new needs, problems, and solutions: new types of museums, spaces, and exhibitions, as well as new types of critical and creative curators, including the "curator as artist." It would only be a question of time before these new possibilities would be organized; it is perhaps just here that the work of the independent curator comes in.

 Seth Siegelaub was born in the Bronx, New York City in 1941, and grew up in New York City. He has been active as a plumber; art dealer, publisher and independent exhibition organizer, including the "Artist's Rights Agreement"; a researcher and a publisher of left books on communication and culture; a bibliographer of the history of textiles; and a researcher studying the theory of time and causality. He has lived in Europe since the early 1970s and currently lives in Amsterdam.

Susan Sollins

Creating and Curating: ICI

Works by IRWIN and by Fischli
and Weiss in *Team Spirit*,
Cleveland Center for Contemporary
Art, Ohio, 1991

ICI was founded in late 1974 on a wave of high spirits and energy,
intellectual joie de vivre, a passion for the art of that time—the late
1960s and 1970s—and the youthful naïveté that encouraged a go-for-
broke mentality. Created as a contemporary art museum without
walls, intentionally without an exhibition space and unencumbered
by institutional restraints, ICI was free to serve then-active artists by
showing their work in a wide variety of spaces and communities that
had no access to contemporary art. There was no "investment capital":
the organization had to survive at first on the earnings from the
projects we developed or were asked to work on. The first of these,
for the 1975 São Paulo *Bienal* Commissioner Jack Bolton, was the
coordination of that year's official U.S. entry, *Video Art U.S.A.* It was
overlapped by the organization of two of our first exhibitions, *Art
in Landscape* (1976–77), which I curated, and *The Sense of the Self:
From Self-Portrait to Autobiography* (1978–79), curated by ICI co-
founder Nina Sundell. In retrospect, these seem to have been
landmark exhibitions, for their ideas remain valid and those artists
who were young turks and whose work we included in those shows
are now part of the establishment—at least that part of it that is
concerned with the art of the recent past.

We were committed to what we called "idea" exhibitions, each of which was based on a clearly stated topic, explored through the physical juxtaposition of objects and discussed in a substantial catalogue essay. It was through such a cumulative lens, we believed, that viewers could better understand the individual works and grasp the core ideas of each exhibition, and that we, as curators, could make original and unusual juxtapositions of works as long as each work clearly related to the topic that provided the intellectual framework for the exhibition.

Without a space of its own, ICI had to convince other institutions to participate in its exhibition tours. As a result, we soon had to develop a method of refining and honing exhibition concepts and content through collaborative dialogue. At first, it was a dialogue of two. Later as ICI grew, the dialogue became a written exchange between each prospective curator, and ICI staff, and exhibition committee members—an astute group of artists, critics, and curators—followed by an intense and lengthy working relationship between the curator and ICI's exhibition coordinator or director. We had to be convinced, first of all, of the strength of an idea for an exhibition, and then that the works of art on the proposed checklist explicated or related clearly to the curatorial premise. Unlike most curatorial practice in which the exhibition is designed for a specific known space, at least for the first venue of a tour, ICI's exhibitions had to be adaptable to many spaces. The exhibition concept had to be so clearly stated and persuasive that a distant museum director or curator could convincingly imagine an exhibition in his or her own gallery space and also be able to present it to an in-house committee or board for approval. And the ICI exhibition—an exhibition of contemporary art—had to be as fresh in its last public presentation as in its first, since its life span could easily encompass a period of four or five years from the initial written announcement to its final venue. The in-house ICI dialogue, there-fore, was always intense, a rigorous debate in the form of curatorial question and answer, proposition and defense. Why is this work included in this exhibition? How does it relate to the concept? How does it function visually? How does it relate to the other works in the

exhibition? Why does this conjunction of artwork and ideas constitute the basis for an exhibition rather than material for a book? The context of the entity as a whole was extremely important. We needed to prove to ourselves that each exhibition functioned as a visual and experiential entity, and not as a didactic literary exercise with work of art applauded.

What, then, are the ICI curatorial "verbs" that can serve any curator? *Talk* with the artists; *look* intensely at their work; *be receptive* to new work and new ideas; *communicate* with colleagues; *debate and discuss* your ideas; *find relationships* between works of art; *analyze*; *refine*; *clarify*; *refine again*; make connections; *find the context*; *be critical*; *prove your concept* is valid in the selection of works; write clearly; *think visually*; *go for broke*.

Susan Sollins, born Washington, D.C.
Current position: President and executive producer, Art 21, Inc., New York. **Former positions** include executive director and co-founder, Independent Curators International; curator and chief of museum programs, Smithsonian American Art Museum, Washington, D.C. **Selected exhibitions**: *Eternal Metaphors* (1989–92, ICI traveling exhibition); *After Matisse* (1986–88, ICI traveling exhibition); *Team Spirit* (co-curator, 1990–92, ICI traveling exhibition); *Art in Landscape* (1976–77, ICI traveling exhibition)

Nancy Spector

Subtle Interventions

Installation view of
Felix Gonzalez-Torres, 1995

Having worked at the Guggenheim Museum since 1984, I have
become keenly aware that no object or action exists independently
from its context. Each acquisition, exhibition, and publication bears
the weight, for better or worse, of the museum's institutional
framework. I've realized recently that every undertaking—whether
a large-scale retrospective or a focused collection show—is billed as
"major" or "significant." At the Guggenheim or any other museum
of twentieth- and twenty-first-century art, there is little room for the
quiet experiment or the modest improvisation. And even if there
were, such ephemeral phenomena would be subsumed by the over-
arching profile of the organization and the value system inherent
to it. I have often wondered whether it was possible to reconcile
exhibiting truly innovative art at its moment of inception within
the legitimizing machinery of the museum.

It was Felix Gonzalez-Torres, with whom I had the privilege of
working in 1995, who taught me that the best place from which to
critique a situation is from its very center. His was a strategy of infil-
tration and intervention: to gain entry into the institution and seduce
its audience with a vocabulary of great formal beauty, which speaks
out, ultimately, against homophobia, racism, violence, and other
manifestations of social injustice. The fact that Felix gave his work

away further disrupted the public's assumptions about art sequestered in a museum. It also succeeded in destabilizing the Guggenheim's own day-to-day operations. His generosity, in effect, necessitated the generosity of the museum—to the tune of hundreds of thousands of sheets of papers and tons of candy, which had to be reordered halfway through the exhibition, endlessly replenished, and constantly maintained. Any discontent with this was quickly dispelled as the exhibition itself spread into the streets like a virus, as the artist used to say. Groups of schoolchildren visited the museum with plastic bags to fill with sweets. Sheets from the paper stacks were visible all over the city, rolled and tucked under people's arms, taped to walls in café restrooms, sometimes even wafting in the breeze across Central Park.

From Felix, I learned to test the limits of the possible within the confines of the institution. This has most often been realizable in small, subtle gestures that, hopefully, will make a difference in the long run: for example, rewriting the museum's guidebook in alphabetical format to avoid the hierarchical and teleological impulses of chronological order; expanding the museum's collection, through the addition of work by women artists and others whose voices have been overlooked by the modernist canon; and bringing younger and younger artists into the exhibition program. Such actions are hardly revolutionary, but within the context in which I work, they disrupt the status quo, creating minute ripples in the system that might, someday, form a wave of change.

Nancy Spector, born, Albany, New York, U.S.
Current position: Curator of contemporary art, Solomon R. Guggenheim Museum, New York. **Former postions** include assistant curator, Museum of Contemporary Art, Houston, Texas; research assistant, Department of 20th-Century Art, Metropolitan Museum of Art, New York. **Selected exhibitions**: Berlin *Biennial* (co-curator, 1998); *Andreas Slominski* (1998, Deutsche Guggenheim, Berlin); *Past, Present, Future*, in Venice *Biennale* (adjunct curator, 1997); *Felix Gonzalez-Torres* (1995, Guggenheim Museum); *Rebecca Horn* (1993, Guggenheim). **Selected publications**: *Guggenheim Museum Collection A–Z* (New York, 2001); *Hiroshi Sugimoto: Portraits* (co-curator, New York, 2000); *Felix Gonzalez-Torres* (New York, 1995)

Robert Storr

ICI – Questions and Answers

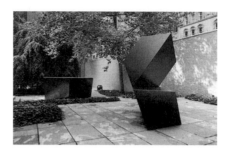

Installation view of
Tony Smith, 1998

1. *What is the single most important piece of advice you would offer a beginning curator of contemporary art?*

Go for art that poses a problem for you rather than toward art that automatically suits your taste or preconceptions. In preference to working out of a theory or dogma or predetermined idea about the art in question—whether it be a theory of your own devising or one borrowed from somebody else—you should work out of your doubts and uncertainties about the work and your evolving responses to it. In that way, you are closer to the position of the general viewer—and in a certain sense you may also be closer to that of the maker who does something and then wonders about what he or she has done. Exhibitions should not be thought of in terms of arguing or "proving" a thesis, but rather in terms of "thinking out loud" about a topic or group of things—but of thinking with objects and spaces rather than words. The issue is how to use what you don't know for sure but have a hunch might be true of the art you are dealing with, as a guide toward finding a way to "phrase" the presentation of the whole and make each element fully articulate in its own right. And at every stage—from curatorial wish list to installation—if the work does not reveal itself, go back and "rephrase" what you have done, trusting intuition over formula, the value of tension and surprise over that of

decorative flow or show-and-tell didacticism. In good exhibitions, strange art stays strange, and familiar art begins to look strange again. To that end, it is always better to be interestingly off-the-mark or "wrong" than boringly predictable and "right."

2. *For whom do you curate? To whom (or what) are you accountable?*
MoMA has a huge, and diverse audience—professionals, dedicated amateurs, lay people of every background and every level of understanding, artists—so you can't do shows for one particular part of that audience and ignore the others, nor can you do shows for a hypothetical "average" viewer. Instead, you have to pace and texture exhibitions so that they can be experienced in different ways that make the most of what the various viewers bring to the work. And you have to have faith in the notion that "ordinary" people prompted by curiosity can learn with their eyes and will tolerate the interim discomforts of confronting unknown and even unsympathetic material. In the final analysis, though, I am most accountable to the art itself, and to making sure that it is not misrepresented in the service of any extra-artistic agenda. Before deciding on what to show and how to show it, curators should swear to their version of the Hippocratic oath: "Above all, do no harm." That said, artists are not always the best arbiters of what's best for their work in a museum context. Like serious writers, they need serious editors. Some need them more than others, of course, but I can scarcely think of a show where an artist has dictated to a curator exactly how things should be presented without making damaging mistakes. Curating is not an art, but it does require a level of engagement, specialized talents, and the ability to improvise in the exhibition medium, which some artists possess but many lack.

3. *Which moment do you curate for?*
Now—plus the time it takes to do the show. It's complete folly to try to predict what art will be like in five years. The field is littered with critics and curators who tried to steer history in this direction or that. At best, you can catch the emergence of a complex of new possibilities

(as Kynaston McShine did in *Primary Structures* or Harry Szeemann did in *When Attitudes Become Form*), but you can never guess what the best exponents of those ideas will do with them in the long run. Meanwhile, the still younger artists who will push off of those ideas in wholly unexpected ways are already formulating their sensibilities in the background and getting ready to disrupt whatever evolutionary schemas you concoct. Curators should avoid speaking in the future tense; the past tells us how treacherous that can be, and the present tense gives us plenty of latitude to say what we have to say. Anyway, it's good enough for me.

Robert Storr, born 1949, Portland, Maine, U.S.
Current position Senior curator, Department of Painting and Sculpture, Museum of Modern Art, New York. **Former positions** include professor, CUNY Graduate Center and Harvard University. **Selected exhibitions**: *Tony Smith: Architect, Painter, Sculptor* (1998, MoMA, New York); *Robert Ryman: Paintings 1955–1993* (1993–94, Tate Gallery, London, traveling exhibition); *DISLOCATIONS* (1991–92, MoMA, New York). **Selected publications**: *Gerhard Richter: October 18, 1977* (New York, 2000); *Modern Art Despite Modernism* (New York, 2000); *Philip Guston* (New York, 1986)

Harald Szeemann

Does Art Need Directors?

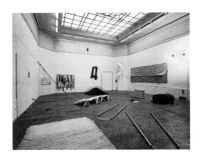

Works by Eva Hesse, Gary Kuehn,
Rainer Ruthenbeck, Bill Bollinger,
Richard Tuttle, Keith Sonnier,
Markus Raetz, and Alan Saret in
When Attitudes Become Form, 1969

Does art need directors? The answer is a decisive "No." Directing clearly refers to the world of the theater, not the fine arts. So, let's forget about directors and talk about professional exhibition organizers, authors, or, better yet, curators. After all, the word "curator" already contains the concept of care.

In my own experience, I have come to believe that an exhibition should be arranged in space as a nonverbal witness to the curator's understanding of an artwork, an oeuvre, an overall vision, or a self-chosen topic. In the process of what in English is usually called "exhibition design," these elements are transformed into events using a fixed, newly interpreted, or temporary architecture. Common devices include establishing breathing room with reference to the artworks, taking advantage of concentrated or expanded sequences of presentation, introducing a celebratory quality by isolating the works, defining eye levels and the dimensions of pedestals, the colors of the walls, the neutralization of floor patterns, the lighting. In short: I participate in the creation of a little poem or a drama, or even of apparent chaos, with every fiber of my curator body, my curator heart, my curator soul. If it succeeds, such an exhibition design does the artwork a true service and has, so far, never destroyed its autonomy.

This is especially true if the curator knows where his or her limits

are. In contemporary art, they are automatically defined in the course of preparing the exhibition with the artists. There are artists who use the characteristics of the space directly as a sculptural quality, and hence supply the exhibition design themselves; Richard Serra is a good example. Then there are approaches that are critical of institutions and need the curator's input (Daniel Buren). Finally, there are some who allow the form of presentation to become part of the work (artist museums), but then again, the work is ultimately placed by the curator. Designing an exhibition can also mean allocating the appropriate space for complex and poetic works in which not only the form of the presentation but also the place is the subject of visualized reflection (Marcel Broodthaers, Christian Boltanski, Reinhard Mucha). Indeed, today more than ever, if an exhibition space is prepared so that it projects the proper degree of consecration, it is possible to make the utopian substance of the works—the immaterial aspect of the creation—visible and experiential, show the greatness in things large and small, solid and intangible.

Autonomy entails self-assertion and self-determination. I do not believe that an exhibition's layout affects either; after all, the curator is not one who critiques the works, but who wishes to present them as autonomously as they truly are. No problems arise in this regard where the artist delegates the presentation to the curator. But the delicate quest for poetic direction while respecting a work's right to autonomy can become an adventurous balancing act. This is particularly true when disparate elements by different artists relate to each other in open space, and any change requires a reassessment of the desired whole. If the artists are present, the whole affair becomes even more exciting, until the discussion leads to the design phase, which involves juggling distances, gaps, and rearrangements motivated by "inner" considerations.

Of course, there are slightly overwrought forms of exhibition design, too. For a while, confrontation for confrontation's sake was at the forefront of curatorial strategies. This may well have been appropriate for contrasting certain pairs of opposites, but in most cases one would have preferred to see the artist's works in the autonomous environment of a white cube. The thing is, people usually forget that designing an exhibition is first and foremost the fruit of investing time in the work, and only secondarily an investment of time in the presentation (and, added

168

to that, the time-consuming administrative work of correspondence and loan documentation). In other words, it is a form of meditation, a kind of meditation that embraces flexibility.

Such examples demonstrate when and where I am in favor of exhibition design. Old works of art can sometimes also benefit from being released from the strangling effects of standard museum hanging. When given new breathing room, they can be seen afresh and from a contemporary perspective. The point of all this is to open up to experience the dimension in the artwork that was once referred to as liturgical and that points beyond its outward appearance. I am opposed to exhibition design that fails to expose the obsession of the creator and the intensive intentions in the work. In that spirit, more power to exhibition design, because it has the capacity to reveal new, nonverbal levels of meanings and new energies for others' reception. And since it is temporary, it is a means to test the works' endurance, and that can never do any harm—at best, it can only make their aspiration to become eternal more colorful. The often-evoked "autonomy" is just as much a fruit of subjective evaluation as the ideal society: it remains a utopia while it informs the desire to experientially visualize the *unio mystica* of opposites in space. Which is to say that without seeing, there is nothing visionary, but that the visionary should always determine the seeing. Otherwise, we might just as well return to "hanging and placing," and divide the entire process "from the vision to the nail" into detailed little tasks again. How sad this would be, for designing exhibitions means making visible the joy of dealing with art, and the joy of the potential combinations it provokes, especially when you consider it to be autonomous. To make exhibitions is to love.

Harald Szeemann born 1933, Bern, Switzerland
Current position: Director of visual arts, Venice *Biennale*. **Former positions** include independent curator, Kunsthaus, Zurich; artistic director, *documenta V*, Kassel, Germany; director Kunsthalle, Bern, Switzerland. **Selected exhibitions**: *Der Hang Zum Gesamtkunstwerk* (1983–84, Kunsthaus, Zurich, traveling exhibition); *Bachelor Machines* (1975–77, Kunsthalle, Bern, traveling exhibition); *Happening and Fluxus* (1970–71, Kunstverein, Cologne, Germany, traveling exhibition); *When Attitudes Become Form/Live in Your Head* (1969, Kunsthalle, Bern, traveling exhibition)

Marcia Tucker

Become a Great Curator in Six Simple Steps!

Work by Liza Lou in *A Labor of Love*, 1996

Live humble. Curators, like critics, run the risk of seeing themselves as the experts, as powerful arbiters of taste and ultimate determiners of "quality." It's easy to think that your opinions, choices, and ideas are the right ones. But if you're fortunate, you may come to see that the strong opinions you hold aren't necessarily based on experience; that the choices you make aren't always the best ones; or that the great ideas you have aren't necessarily relevant to the task at hand.

Ultimately, I've learned most from what I *didn't* like, not from what I thought was wonderful. Finding out why you aren't interested in something helps you to understand where your own prejudices and resistances lie. Unfamiliar forms of artmaking (or anything else, for that matter) have a tendency to be read at first as having no form at all—a challenge which, in my early years as a curator, led me to inadvertently put my coat down on the work I came to see, or to make profound comments about something that turned out not to be a work of art at all. It really helps to keep an open mind, have a sense of humor, and take your own likes and dislikes with a grain of salt. If you can look at your own curatorial work and admit its ongoing flaws and limitations (as well as forgive them), you know you're growing professionally as well as personally.

Enjoy the trip without needing to know your destination. I always felt fortunate that I never had a "career." I didn't strategize about where or when I should be at a given point in my professional life, or what I should do to get there; I tried to pay attention instead to the work I wanted to do, and what I needed in order to do it. It's good to remember that you can always find or create viable options that are outside the system.

Put the artist first. The most important attitude you can bring to curatorial work is respect for the artist and the artistic process. Being a curator isn't just a matter of organizing exhibitions and catalogues, but involves supporting artists and the creative enterprise on every level. This job ranges from the mesmerizing to the mundane, and includes writing recommendations (for studios, grants, visas, jobs, apartments, tenure, and more), suggesting resources, making connections, and above all going to artist's studios constantly, even—or especially—when you aren't working on a show.

Don't forget who you're talking to. Know who your audience is, and try to communicate in a language that's likely to be understood, without talking down to others or assuming specialized knowledge on their part. To do this requires a recognition of the importance of educational know-how in the formulation of exhibition design and practice, and a willingness to collaborate with others. If curators and educators worked hand in hand on projects from the outset, exhibitions might look and feel refreshingly different, offering interpretive contexts designed to generate independent thinking and to change the viewer's experience from a passive to an active one (besides making sure that exhibitions always include comfortable places to sit down!).

By speaking honestly and from your own experience, in the first person, you encourage others to form their own ideas and opinions and/or to identify with or expand upon yours. Hiding behind a mask of authority and supposed objectivity can short-circuit curiosity and alienate those who want to participate.

Remember to ask yourself what you're doing and why on a regular basis. Looking at art has given me my education—it's taught me philosophy, science, mathematics, literature, history, and music, to name just a few—and it's taught me to see what I couldn't see otherwise. I'm not interested in trends, movements, "top picks," or art forecasting, which strike me as nothing but marketing strategies. In my curatorial—and my everyday—life, I always hope not only to learn something, but also to surprise myself. This means taking risks, trying to do things differently, and working without knowing what the outcome will be—something that artists do every day.

But institutional thinking tells you to look very, very carefully before you leap—which virtually guarantees that you'll never leap at all. As an antidote to this, my motto has been "Act first, think later—that way you'll have something to think about." For me, the most rewarding places from which to learn have been my mistakes. At the same time, perhaps there are no mistakes—there's just more than one right way to do things.

Put your work in a larger context. If exhibitions of contemporary art don't stress the relevance of art to other fields of endeavor, modes of inquiry, and ways of being in the world, including the ordinary, if art is seen only in the context of other art, of art history, and of the formal language of art, what value does it really have?

 Marcia Tucker, born 1940, Brooklyn, New York, U.S.
Current positions: Independent writer, lecturer, art critic, stand-up comic. **Former positions** include founder and director, New Museum of Contemporary Art, New York; curator of painting and sculpture, Whitney Museum of American Art, New York. **Selected exhibitions**: *The Time of Our Lives* (1999, New Museum); *A Labor of Love* (1996, New Museum); *Bad Girls* (1994, New Museum); *Richard Tuttle* (1975, Whitney); *Bruce Nauman* (co-curator, Whitney, traveling exhibition). **Selected publications**: Series editor, *Documentary Sources in Contemporary Art*, vols. 1–5 (New York and Cambridge, Massachusetts); *Talking Visions: Multicultural Feminism in a Transnational Age* (New York, 1999); *Out There: Marginalization and Contemporary Cultures* (New York, 1990); *Discourses: Conversations in Postmodern Art and Culture* (New York, 1990); *Blasted Allegories: An Anthology of Writings by Contemporary Artists* (New York, 1987); *Art After Modernism: Rethinking Representation* (New York, 1984)

Barbara Vanderlinden

Asking the Right Questions

Laboratorium, 1999

In spite of everything, the traditional exhibition continues to be a kind of self-fulfilling prophecy in which the materials get showcased or entombed. Nonetheless, some curators today are trying to move beyond the practical, selective tasks of these showcases and challenge convention by presenting different curatorial ideas and experiments. Instead of the institutionalized models of the 1980s and 1990s, today curators seem to be moved by conceptual concerns first touched on in the 1960s and 1970s. Through such experimentation, the curatorial practice challenges different modernities and also becomes multi-disciplinary, and thus appears to progress in direct dialogue with the developments in cultural, political, and intellectual production. Curators thus can be understood as practitioners in relation to other practices: art production, criticism, theory, politics, sociology, etc.

In the course of developing such exhibitions, one of the underlying ambitions of my curatorial practice has been to reveal the exhibition's vitality simply by treating the production of the exhibition as a real-time process. The experiments we undertook in shows such as *Indiscipline* and *Laboratorium* are of translation: to move from one form to another and from one discipline to another, where the materials and ideas of different disciplines, and from different historical backgrounds, cross in the exhibition; where they can be interpreted,

decoded, or deconstructed if necessary, in order to create a vital dialogue between different concepts, forms, and ideas given to contemporaneity. This can be a process of clarification and intensification, or of their opposites. Somehow we have tried to make the forms, the events, the dramas, and the plays of the different mediums and different modernities speak in and through each exhibition we have organized. The exhibition is in this sense an intermediary that intensifies this process of clarification between what art produces and what happens in a broader context. With this mixture of process, production, theory, and exhibiting in mind, a true vade mecum of a curatorial practice has to be more multifaceted than a practical guide or guidelines to the various aspects of selecting the art and the setting and organizing an exhibition. The most common procedures as well as the suggested alternatives cannot be satisfactory or adequate, since we mostly embark on such exhibitions and projects with a wide range of questions instead of advice, rules, or guidelines.

Barbara Vanderlinden, born Ninove, Belgium
Current positions: Director of Roomade, Brussels; freelance curator, Belgium. **Selected exhibitions**: *Indiscipline* (co-curator, 2000, Roomade); *Laboratorium* (co-curator, 1999, Antwerp, Belgium); *Generation Z* (co-curator, 1999, P.S.1, Museum of Contemporary Art, New York); *Two Hours Wide, Two Hours Long* (1998–99, Centro Cultural de Bélém, Lisbon, Portugal, and Museum of Fine Arts, Antwerp); *Manifesta 2* (co-curator, 1998, Luxembourg); *Office Tower Manhattan Project* (1997–99, Roomade); *Matt Mullican Under Hypnosis* (1997, Roomade); *On Taking a Normal Situation . . .* (1993, Museum of Contemporary Art, Antwerp); *New Sculptures* (1993, Middelheim Open Air Museum, Antwerp); *The Sublime Void* (1993, Museum of Fine Arts, Antwerp). **Selected publications:** *Laboratorium* (Antwerp, 1999); *Two Hours Wide, Two Hours Long* (Lisbon, 1999); *Manifesta 2* (1998, Luxembourg)

Igor Zabel

Making Art Visible

Works by Yuri Leiderman, Mladen Stilinović, Jože Baŕsi, Heimo Zobernig, and Uri Tzaig in *Inexplicable Presence: Curator's Working Place*, Moderna Galerija, 1997

It has often been said that one essential task of the curator is to construct a space for the work of art—physical space as well as mental, social, etc. A work can only be seen and experienced in an actual context; its existence per se (i.e., outside any such particular context) is only an abstract idea. The curator can therefore essentially affect the reception of the work without actually becoming an artist.

Of course, today when the idea of art is no longer connected only to a specific type of object but often to constellations, relationships, and interventions into different contexts, this division is less clear, especially since both activities seemingly tend to meet in an intermediate area between them. Still, I would say that the curatorial activity cannot replace the artistic production, and it cannot exist if there is no artistic production; the task of a curator is not the production of works of art but the production of the conditions of their display and visibility (in the broadest sense). This is a polyvalent and multilayered activity. Simultaneously, it includes a wide range of attitudes and approaches, from the very rational and pragmatic ones to more emotional and even irrational ones.

A curator never works in a clear and neutral space; his or her activity is therefore a response to particular determining conditions. For example, as somebody coming from the area of so-called Eastern

Europe, I experience how the work of artists, critics, and curators from this area is a priori caught in a specific system of assumptions (of cultural difference, etc.), and how often we are expected to "represent" a particular "identity," etc. It therefore seems almost unavoidable to reflect these ideas and to try to build an effective strategy to deal with them.

Repeatedly in my own practice, I experience how decisive small, accidental, and marginal events can be. One is often haunted by images or expressions seen or read somewhere by coincidence, by uncertain memories, and small personal obsessions. Coincidence, too, can be a decisive factor. I often ask myself whether it is possible to incorporate this aspect of the marginal and coincidental deliberately and actively into the process of constructing a show, thus exposing the decisive but hidden pre-conditions of this process and consciously dealing with them.

Certainly, the question is, Why should one's marginal personal obsessions and preferences be so important that they could form the basis for the curatorial construction of the space for art? I believe that, in order to turn them into something of more general interest, one should basically use them as a starting point for a dialogical process with art and artists. Only through such a dialogue and the relations within it can they be developed into a more generally interesting field, eventually (and this is essential) throwing a particular and, hopefully, fresh light on the works of art themselves.

Igor Zabel, born 1958, Ljubljana, Slovenia
Current position: Senior curator, Moderna Galerija, Ljubljana, Slovenia. **Selected exhibitions**: *2000+ — The Arteast Collection* (co-curator, 2000, Ljubljana); *Aspects/Positions* (co-curator, 2000, Vienna); *Manifesta 3* (co-curator, 2000, Ljubljana); *33rd Zagreb Salon* (1998, Zagreb, Croatia). **Selected publications**: *L'autre moitié de l'Europe* (Paris, 2000); *After the Wall* (Stockholm, 1999); *Connected Cities* (Duisburg, Germany, 1999)